FAMILIAR

THE FAMILIAR

A Life in Weekly Instalments

Roddy Phillips

The Press and Journal

BLACK & WHITE PUBLISHING

First published 2009
by Black & White Publishing Ltd
29 Ocean Drive, Edinburgh EH6 6JL

1 3 5 7 9 10 8 6 4 2 09 10 11 12 13

ISBN: 978 1 84502 253 2

A CIP catalogue record for this book is available from the British Library.

Front cover painting: 'The Familiar' by Catriona Millar
www.catrionamillar.com

Cover design: richardbudddesign.co.uk

Cover photography: iStock

Typeset by Ellipsis Books Ltd, Glasgow
Printed and bound by MPG Books Ltd, Bodmin

This book is dedicated to my wife Catriona because she walks faster.

Contents

Foreword

OVER the years, in dealing with columnists in my capacity as a features sub-editor on the *Press and Journal*, I have come to recognise what makes the rarer talents stand out.

Insight, humour, an eye for the absurd and the downright ludicrous and an ability to filter the everyday to extract the extraordinary are essential tools of the columnist's craft. Roddy Phillips has an abundance of these tools at his disposal.

Of course, it doesn't end there. Sometimes subtlety is called for; sometimes a sledgehammer touch; always an insatiable appetite for seeking out and understanding the human condition.

The day-to-day banter of family relationships the ups and downs of village life and the vagaries of dealing with shop assistants, tradesmen and the jobsworths we all know and loathe give Roddy a rich source of material.

The art of observation is high on the agenda. What to most people would be a simple scene of passing interest can, when seen through the right eyes, Roddy's, turn into a wide-ranging and fascinating reflection on life. When reflection turns to rant, watch out. Sparks will fly.

In addition to his splendid columns, Roddy also writes criticism for the P&J on theatre, music and art. What has always amazed me is how while taking in the subtleties of a performance, analysing it to come to a fair, if personal, opinion of the merits, or not, of the work on display for his review,

Roddy can still find a corner of his mind where he can store away some peripheral event or character that he has observed which will give him the foundation of an often hilarious column at a later date.

Occasionally, Roddy will take the column on the road, to his beloved Lake District or Tuscany. The new surroundings met by the Phillips roadshow spark him into further reflections on the state of the world, the idiosyncrasies of the locals and his fellow-visitors and we, his readers, are the beneficiaries.

Sometimes, his analysis of what he observes seems to stun even himself. It really can be a weird and wonderful world.

To keep a regular column going over many years, making sure it remains fresh and interesting, is no easy feat and many fall by the wayside. Roddy has stood the test of time and he remains that rare phenomenon, a columnist that readers look forward to with anticipation.

Enjoy this collection of his work. It will make you laugh, it will make you think, and there might even be a warm glow to be had along the way.

Tom Forsyth

The Gift that Keeps on Shrinking

ANY Christmas parcel from a relative that looks remotely squidgy is greeted in our house by tears before turkey, so it's always best to filter out such suspect parcels before they create untold damage on the big day.

Basically, the bigger and softer the parcel the worse the effect, because it means one of our relatives has decided we would be utterly enchanted by an embroidered toilet cistern jacket or a Peruvian pampas grass dog-blanket for the dog we don't have.

These are the worst kind of gifts because you can't immediately guess what they might be, so you open them with immense optimism and when they turn out to be a Harry Potter alarm clock or, my personal best of last year, a stamp wallet embossed with my initials, the disappointment overwhelms you until, of course, you think of someone you can send it to.

There was only one big squidgy parcel to deal with this year, but it looked like a challenge from every angle. It even had the nerve to arrive a week early, bringing with it all sorts of unpleasant memories of its predecessors, combined with a curious presentment of brazen defiance.

I had it down as a family big slipper and was willing to give it some space. Rural life is riven with icy draughts of Dickensian proportions. Although they might bring an air of Victorian authenticity to the festive season, it's an air that's generally below freezing.

My wife wasn't so sure. She had a bad feeling about the contents of this parcel and on its arrival it had been swiftly put to one side in the conservatory. The fact that it had made it through security meant nothing; it was still in

gift limbo and the likelihood of it ever making it to the next stage was slight, to say the least.

It lurked around the conservatory for a couple of days causing trouble and general unease until it was stealthily repositioned in my study. Apparently, when it was opened, I was to put it immediately on eBay.

My wife had torn a hole in the wrapping paper and revealed something brown and woolly hiding within.

I was intrigued and every so often last week I gave it a cursory poke, hoping for some kind of reaction. A scream or a groan would have been great, but I assumed I'd have to wait until the parcel was unwrapped for that kind of thing.

Then, last Saturday morning, my wife pounced on it.

"Right," she shouted, "this thing's annoying me."

She then immediately began laying into the wrapping paper, which at first put up a reasonable but ultimately pointless fight.

Out came what I thought was a monkey suit of some description and jokingly I said I would have it, but my wife had a strange look about her. She looked slightly suspicious then deeply thoughtful, then faintly surprised.

"Actually, this is rather nice," she said, smiling.

"As monkey suits go, I would say it was one of the best I've seen," I added, then started reeling off a list of possible people we could send it to.

"Do you mind; it's a chunky Angora wool cardigan and I quite like it," returned my wife.

I would have been amazed if I had believed her. For a start, it was huge and if it hadn't been for the sleeves and the buttons I would have said it was something you could lag the tank in the loft with.

In fact, it would have made ideal insulation.

"I think it's for both of us," I said, and promptly slipped an arm into one of the sleeves. My wife followed suit and we stood there in front of the hallway mirror like a two-headed woolly monkey.

Personally, I couldn't see the attraction, but for some reason my wife saw potential in it, even if it was at least a size twenty.

"I think that's just the style of it," said my wife, trying to convince herself

as she posed around in front of the mirror. Suddenly it dawned on me that she might be serious.

"But it's too big for both of us put together and it's ghastly," I laughed.

"Says the man who thinks hot pants are still in fashion," retorted my wife.

"That's just wishful thinking," I replied, then sloped off.

I had forgotten about the cardigan until Christmas Eve morning when I heard my wife scream. I found her standing by the washing-machine holding something guiltily behind her back. Her face was drained of colour and she was trembling.

"You know that expensive Angora cardigan?" she asked nervously.

"It was expensive, was it?" I asked.

"Don't rub it in; I tried to shrink it," screamed my wife, then from behind her back produced this strange shrunken brown headless torso, the sort of thing you would have seen in a Victorian freak show.

My first instinct was to make a run for it, so I did, with my wife hot on my heels waving this weird thing at me like it had voodoo powers. Even from the other end of the room I could barely bring myself to look at the gruesome article, it was so strange and creepy.

Just to make matters worse, my wife tried to put it on, hoping it would spring back to its former size, but I doubt if it would have fitted a four-year-old.

Strangely, even although she struggled hard with it and managed to get an arm halfway up each sleeve and then had to escape from it like a wailing madwoman from a straitjacket, the cardigan reverted in an instant to its tiny, perfectly formed self.

The little old lady in the charity shop lit up when she saw it.

"Now, I would have worn that if it had been a bit bigger," she said brightly as she examined it closely. "Oh, it's a man's cardigan; I thought it was a lady's," she added, looking up at me.

"I think it's optional now," said my wife as she swiftly left the shop.

Dancing Queens

WITH Hogmanay looming, it was time to head for the hills. It's not that we're antisocial, we just like hills, particularly when they're reflected in wide, flat lakes; a combination best viewed, I find, from the panoramic windows of a luxury holiday apartment.

Obviously, the opportunities of entertaining tall, dark strangers after midnight in such circumstances are greatly reduced, which is another attraction of going AWOL at such a time of compulsory mass jollity.

When we arrived at frosty Windermere early in the evening, it was the hills that were tall and dark. Standing on the end of the jetty, the lake was a black mirror for the stars while swans moved in silence like shadows around us. It was the sort of scene you want to suck in and store away for a rainy day, so we did, then legged it to our apartment before we froze to death.

I confess to a certain smugness as we unpacked the car. There were only two other cars to be seen and one of them, I reckoned, belonged to a caretaker.

In the morning, I could see the sunlit hills while I lay in bed with one eye open. Fortunately, from my prone ever-smug position, I couldn't see that the car park was now full because everyone had been sneakily dining out the previous evening.

"Maybe they're just visiting," said my wife hopefully as we stared out of the great panoramic windows at the rows of cars and massive people-carriers.

"I think so," I agreed. "Who would want to go to the Lake District for Hogmanay?"

"Exactly," said my wife, and off we went to join a traffic jam that stretched for two miles either end of Ambleside.

"I suppose there's just a lot more people in England," I said as we sat and watched hundreds of them walking purposefully along the road before disappearing up promising, mysterious footpaths.

Eventually, we joined quite a few of them at frozen Elterwater for what amounted to a sort of mini marathon walk. The path around Elterwater is only about 6ft wide and at every point of our walk it was brimming over with people and dogs. It was like a mass walk-on display at an outdoor dog show.

Having met and rubbed shoulders with more people and cute dogs than we would normally encounter during an entire year, we headed back for the quiet jetty and the comfort of the dark empty lake.

I could see the lights as I parked the car, dozens of them twinkling suspiciously around the jetty area.

"Must be fireflies," mused my wife, again ever the optimist.

We had never thought of having a barbecue on the jetty in the dark in the depths of winter and inviting thirty or so of our friends along, but from a distance it looked like a great idea, although there was some consolation in the fact that it felt about minus ten.

"I hope they're careful," I said grimly, "you wouldn't want to fall into that freezing water."

"No, not fall in," chimed my wife as we gazed at the party.

"Not with all that music and jollity going on; no one would hear you screaming for help," I added.

"Screaming for help . . ." chorused my wife gravely.

I think the cold was beginning to have an adverse effect on our brains. Upstairs in our apartment, neither of us could construct a complete sentence that made sense, so for at least an hour we sounded like characters in a Harold Pinter play.

A similar effect obviously set in at the barbie on the jetty and eventually it moved upstairs and downstairs, in fact it just filled the place from top to

bottom leaving our apartment like a vacuum occupied by a bunch of Billy No Mates.

Outside, the noise from the party was obviously filtered away across the lake and up into the hills, but once it was contained it was better than your average Radio 4 play. In every room of our apartment, it blasted away in highly realistic surround-sound.

There was a popular bloke called Roger whose idea of a party seemed to consist of goosing all the women and then braying like Sid James when they screamed. Roger was slapped several times, either that or someone had a whip and had brought livestock into the building.

Two of the women stood out in a banshee sort of way. One was called Marge, but the other remained tantalisingly anonymous, probably because she had a penchant for dancing on the tables and didn't want to be sent any bills for the damage.

At around ten minutes to midnight, the whole lot paraded back down to the jetty and the lakeshore to watch the fireworks. At which point, judging by the screams, someone ended up in the water after old Roger gave them a New Year special.

Half an hour later, the real party erupted to the pounding, jangling sound of Abba and much whooping from the table-tops.

"You're in the mood for a dance, and when you get the chance . . . you are the dancing queen, young and sweet, only seventeen . . ."

With little imagination it was easy to visualise the scene and as tempting as it was to join in I decided my dancing queen days were over, or at least in temporary abatement.

"What do you mean over?" retorted my wife, "they never started."

The ravers raved on until we went to bed like a right pair of old codgers sporting earplugs, the bedroom swaying to the strains of Fernando.

The following morning was fresh and crisp and, as we suspected, devoid of any partygoers limbering up for a day's trekking on the fells. Instead, the car park was teeming with elderly jolly hillwalkers, all backpacked and raring to go. They were a spry, friendly bunch, stretching and trotting on the spot. Suddenly, one of the women let out a familiar scream and everyone shouted "Roger".

Apparently, we had brought Hogmanay in with the cast of *Last of the Summer Wine* and they had still beaten us to the hills.

Jammed

FROM the rear of the car, some impossibly jolly twit shouted: "What about a good old singsong?" Worse still, this highly-depressing suggestion was greeted by the rest of the passengers with enthusiastic shouts of "hurrah" and "let's all sing in harmony".

"That'll be a first," I grumbled darkly and was promptly poked in the back of the head.

My wife's idea of a good old singsong, really, is a round of old songs, namely of the Cockney music hall variety. So, within seconds, our car was rocking to the 1909 Harry Castling classic 'Let's All Go Down the Strand'.

A bit of wishful thinking since, at that precise hour, we weren't going anywhere.

"Oh, what a happy land. That's the place for fun and noise," belted out my wife. "All among the girls and boys. So . . . let's all go down the Strand."

"Have a banana," everyone chorused, including myself in a flat monotone mutter as I stared out of the window through the miserable curtain of rain at the car next to us. Three children in the back appeared to be throttling one another while their parents sat like zombies in the front.

"It's quite possible those children have killed their parents," I said as someone drummed on my head with a pair of bananas.

We were now only an edelweiss away from a *Sound of Music* medley and from there we were just a Tony Award from the entire Rodgers and Hammerstein back catalogue.

We had run out of reading material after the first hour, not that I could

read much since I was meant to be driving the car, or at least pretending to drive the car. For a time, we played I-Spy and it was a credit to our powers of observation that we got so much out of the interior of one car and its occupants.

We then acquainted ourselves with the people in the next car and got to know their profiles in some detail. There was great excitement if their lane moved first and a new set of profile people arrived; even greater excitement if we moved more than two metres at one time, because then we either caught up with our old pals or we had to make new friends all over again.

Eventually, there was a short burst of general wailing and chest beating followed by a slightly disturbing twenty minutes or so during which everyone indulged in an individual panic attack.

These took various forms, but all ended in the same way with the panicker being attacked by the person nearest to them and shaken into mute submission. We decided a group panic attack was definitely something we could look forward to, a sort of massive reward treat that dangled teasingly somewhere at the end of our collective tether.

But first there was doh, a deer, a female flipping deer to contend with – in harmony, of course. So much so that no one sang the actual melody line. This produced a bout of laughter that reached a pitch of hysteria that could quite easily have erupted from the car and raced wildly into the wet fields, snarling and drooling, until it vanished into the veil of rain.

This was the point in the traffic jam when we saw our fate stretching before us uphill for at least another three miles into the distance and we fell silent with a sort of bitter respect for our captors.

"You have to hand it to them," mused my wife, "they've made a proper job of it."

Three miles back, when we drove blithely into the traffic jam, we thought it was an accident because we saw flashing blue lights up ahead.

As we slowed to a crawl, we braced ourselves for the possible scene of carnage. Thankfully, it failed to materialise – like the police car, which we assumed had been airlifted to a better world not really that far away.

When you say something like "must be roadworks", you don't imagine for one second that you'll take an hour-and-a-half to cover the next three

miles and that a time will come when you will contemplate running away screaming and leaving your car and its occupants behind forever. But it certainly crossed my mind several times, particularly as my bladder began to reach bursting point.

Almost unbelievably, for the first time in history, I was the only person in our car who was desperate for the toilet. Normally, everyone needs the loo everywhere we go.

In fact, every journey we make is basically just a series of shorter journeys between toilets and the first thing anyone says when we arrive anywhere is "where's the loo?"

"How can I be the only person who needs the toilet?" I demanded.

"Give me another half hour and I'm sure I could whip something up," replied a voice from the back.

It was a generous offer, but there was no point in tormenting myself any longer, so I pulled in, switched my hazard lights on, jumped from the car, ran round the back and launched myself into a dense pine wood which turned out to be on a steep and slippery slope.

Some kind of wild, thorny hedging broke my fall in a spiky embrace, which was just as well because there seemed to be a river at the bottom of the hill.

At least in the wood I was sheltered from the rain, although standing up was tricky until I found a nice thorny branch to cling to. Even in this mud-splattered, torn and tattered state, I felt so liberated I burst out laughing.

However, getting back up the hill turned out to be the most excitement I'd had all day. I made it at the third scramble and emerged panting, my face camouflaged with wet earth like an escaped PoW.

Back in the car, the entertainment committee had broken out the *Oklahoma!* hit, 'I'm Just a Girl Who Cain't Say No'.

"Don't worry," shouted my wife, "only six more shows and we'll get on to Lloyd Webber."

I could hardly wait.

The Fabulous Baker Boy

I WASN'T surprised when our youngest son, Adam, got himself a temporary job in a baker's shop. I've always maintained that it's better to have an interest in your work, no matter how short term it might be, and Adam has always had a healthy attraction to cakes.

Lately, he has been more attracted to the gym.

So either he was embarking on some sort of aversion therapy or he really was just in it for the discount.

Since the baker's shop was in a particularly colourful part of town, he was also going to experience a slice of real life. But I was fairly confident that a 6ft body-builder could handle any tricky customers that might come his way.

But I did get worried the first time I picked him up.

I was early and Adam bolted from the shop like an escaped mad scientist in his white coat – a curious premonition of his chosen future career.

With a nervous eye over his shoulder, he ordered me to park round the corner out of sight. "They'll think we're lottery winners," he said, and ran back into the shop where the impatient queue was turning nasty.

There was a special offer on caramel squares and an old lady in a purple tracksuit and leopard-skin slippers had elbowed two scooter kids into second and third place.

You could have cut the atmosphere with a ladle.

Since everything was prepared on the premises, Adam always came home smelling of freshly baked bread. One sniff and you felt simultaneously

hungry and comforted. Which just goes to show you really can be cuddled by a smell.

This wasn't the only thing Adam brought home. Every evening, we entertained a new character and plot line as Adam recounted the day's events. It was like listening to an episode of a soap opera you didn't like but couldn't resist hearing about.

Most of it was very funny, but quite often my wife and I sat with our mouths open, and thought what sheltered lives we led. It was all very Dickensian.

My favourite character was the woman who burst into the shop every Monday morning and shouted lengthy Bible passages at everyone. Adam said this was a good way to tell the locals from people who had just been driving past and fancied a sticky bun.

After her sermon, the hellfire lady would march up to the counter, parting the queue like the Red Sea, and demand the right to buy two fruit scones. On her way out, she would absolve everyone of their sins.

Adam had to admit that after a few weeks of this it began to lose its appeal, particularly if the shop had a healthy quota of colourful characters already who would add their own distinctive flavour to the proceedings – such as the bloke who had to sing to everyone: 'I'll Take You Home Again, Kathleen'.

Apparently, he was always shocked when people refused to let him move in with them.

True, some of the customers were either inebriated or severely hungover, but most of them had just seen a bit of life, and they stayed for hours to tell Adam all about it.

Scars were held up as evidence and at least once a week, someone would come in with a black eye and a tale of Shakespearean complexity and gothic horror that would curdle the cream cakes.

I think Adam's white coat had something to do with it. A lot of these people probably thought they were visiting a clinic.

Even although there was a police station, or "cop shop", just a few doors down, we were constantly telling Adam to be on his guard – particularly when it turned out that he was either manning the place on his own or, at best, with a tiny woman he had crowned his pet granny.

"She's more of a shop mascot, really," he told me once, so I imagined her perched on the counter, waiting patiently for a lucky stroke. In reality, she was fit for anything or anyone that came her way.

Typically, she wasn't there the day the pie man called; instead, Adam was left in charge with a new girl who was never going to win Family Fortunes.

The pie man was a small, slightly built bloke, described by Adam as a troll.

"He's probably of Scandinavian descent," said Adam, thoughtfully.

Wherever the pie man originated, more recently he had been visiting distant planets.

While taking a brief respite from his galactic travels, he had developed a taste for the baker's steak pies and was renowned for his gloomy manner and "far off" stare.

Adam had been having a bad day when the pie man turned up. The Bible lady had made several extra visits, warning about impending Armageddon, and a giant dog, frothing at the mouth had to be ejected gingerly.

On top of this, Adam had been too busy to have his lunch, so he was not in the best frame of mind when the pie man marched in holding a pie he had bought a few days earlier and slammed it down on the counter.

The top of the pie was missing, so Adam stared down reluctantly at its mashed contents and then told the bloke that he didn't need any extra pies today – he had a shop full of them.

"That's nae steak," barked the pie man, "it's mince."

Deciding not to argue with someone who was visibly on another channel, Adam handed over a replacement steak pie and watched as the bloke ripped off the top, took one look inside, and then slammed it down on the counter with a hideous wail.

"It's still mince," he shouted, his eyes rolling in his head like marbles. Adam offered another steak pie and watched it meet the same fate, as the pie man now began to howl like a wolf.

Adam didn't think he had enough pies for this to go on much longer, so he told the bewildered new girl to guard the shop and marched out.

Down the road, he could still hear the pie man screaming "It's mince" and,

for a moment, Adam toyed with the idea of getting on a bus. Instead, he headed for the cop shop.

Apparently, the policeman almost fell off his seat when Adam strode in with his white coat splattered with blood-red jam.

Thirty seconds later, wearing his armoured vest and carrying his truncheon, the policeman was fit for the fray.

He ordered Adam to stay well back, but the little pie man was already scuttling up the street. The policeman shouted a stern warning at him, then picked up a topless pie from the pavement.

"Is this the pie in question?" he asked gravely. Adam peered at it carefully.

"One of them," he said, and the policeman sighed and shook his head.

Adam gave a statement and the pie was kept as evidence.

Needless to say, Adam now looks back on the baker's with fond memories. If nothing else, he learned that you can't have your cake and sell it.

Barefoot in the Dark

IT SEEMS to be the smallest things that press my wife's panic button. A tiny twig scuttling past her on the road or a sudden shifting shadow will send her up like a rocket. Pheasants are the worst offenders because they're all highly-charged nervous wrecks.

When we're out for a walk and one screeches off in front of us, my wife will be so startled she will be close to collapse.

She reckons the pheasants gang up on her, skulking around in the shadows waiting for her to come within shrieking distance and then once she's a few feet away they let her have it.

She would probably have blinkers by now, but for the fact that she has absolutely no problem with a genuine full-metal-jacket crisis. In fact, she has a superwoman suit permanently concealed about her person. Two years ago, for instance, she waded into a field and pulled a semi-conscious girl from a wrecked car that was on the brink of exploding into a fireball.

A few hours later, she probably screamed the house down because she inadvertently brushed her leg in the kitchen against a dangling tea-towel. I'd probably be a nervous wreck by now if I hadn't formed a scream-proof barrier, although sometimes nothing can withstand my wife's sudden explosions of terror.

The other night, just as we were going to bed, the cottage was so quiet you could hear the frost forming outside on the enamelled road. I was drowsily going about my business, switching off lights, when a sudden scream went through my head like an electric bolt.

The bloodcurdling scream came from the direction of the kitchen or the conservatory, so I waited a second before asking the inevitable question; there was always the chance that my wife had been snatched by a burglar or, even worse, had spotted a mouse. Either way, both had probably died by now of a heart attack.

"Sorry about that," shouted my wife, laughing, "I stood on the arm of a cardigan I was carrying and I got a fright."

A few minutes later, another scream ripped through the house because my wife had repeated the cardigan-sleeve incident on the way out of the conservatory, just to be on the safe side.

I was in our bedroom barefoot in the dark on the way to the little library room when it happened. There was a big clear moon hanging in the library window and I wanted to see it in all its ivory glory. The library is only about six or seven feet deep and it was pitch black apart from a shaft of moonlight illuminating about half the third shelf.

"Don't you dare open that library window," shouted my wife, fearing, of course, that we might freeze to death in the middle of the night. Quite how she knows I'm about to do things when she's in another part of the house is a mystery I've stopped pondering.

Sneaking the window open, I sucked in the brittle, freezing air and for a

moment it made my head swirl and then it cleared like the sky I was gazing at.

Within seconds, I may as well have been standing barefoot in a crypt, it was so cold, so I closed the window and stepped back for another look at the moon.

I might have remained like that for a minute or so taking in the big moon face if I hadn't become aware of something under my right foot. Standing stock still, I tried to work out what I had just stood on: it was soft and furry like a lucky rabbit's paw.

Moving gingerly backwards and switching on the light, I realised it was an unlucky mouse and so without thinking I shrieked.

"What's happened now," shouted my wife.

I was too stunned to reply so, within seconds, my wife was at my back, peering over my shoulder.

"What is it?" she whispered, "did you see something; are you OK?"

"Actually, I just stood on a mouse," I said, matter of factly.

The shriek just about punctured my right eardrum.

"Is it dead? I don't want to see it. Where is it?" said my wife, now hiding behind me.

"I think it's dead," I replied, "I mean, I haven't checked its pulse or anything, although it looks like it's in the recovery position, so it might be OK."

"Did you stand on it intentionally?" asked my wife. "I'm so glad it wasn't me; this is my worst nightmare."

As I explained what happened it began to sound extremely unfeasible.

"So the mouse just stopped behind you and waited for you to stand on it?" said my wife. "Just get rid of it," she continued as she left the bedroom quivering visibly.

"I thought I'd give it a decent burial in the morning," I shouted.

"Now," barked my wife, "and no hymns."

I got the brush and pan out and reluctantly scooped up the mouse, peering at it with one eye in the hope that it might somehow look better, but it appeared to be rather on the flat side.

When I threw it out the little window, I heard an owl swoop down and catch it before it hit the ground.

This actually gave me some comfort because, if the mouse had been outside where it should have been, the owl would have got it anyway.

The next day, still troubled by my barefoot misadventure and brooding over the odd twinge of remorse, I confided in my friend Mike, who I was sure would bring some commonsense to bear on the matter.

He didn't seem too bothered about me standing on a mouse with my bare feet. In fact, I think his experience of mice was more limited than I thought.

"So it's dead, is it? he asked matter of factly.

"Oh yes," I said. "It was bookmark flat."

"Serves it right," he declared, "sneaking about in the dark like that; what did it think was going to happen?"

Folkies

IF THERE was a big TV in the Admiral Benbow Inn, then we were in the right place. There were four tough pirates propping up the bar smoking into their beer and the landlord grinning in front of them displaying his cavalier attitude to modern dentistry.

"Which one do you think is Blind Pew?" asked my wife, as we hovered in the doorway.

I didn't think he had turned up yet. Apart from the four hard smokers, the pub was suspiciously empty.

After being invited down to hear a "crackin' folk session" and being blown into the pub by a howling wet gale, we assumed we would met by a rollicking scene straight out of *The Jolly Beggars*. Instead, there was a debate rumbling round the bar about whether Nick Berry had made a wise career

move leaving *Heartbeat*. Nick was up on the wall-mounted TV working undercover on a villainous blonde model with a spacious dockland loft apartment. A fifth serious smoker appeared, shuffling back from the Gents. Tugging up his tracksuit bottoms, he announced with a passing glance at the TV that the blonde did it.

There was an outcry; pints were thumped down on the bar, and fags were smashed out until a skinny bloke with a pony-tail and a long earring realised it was a new series they were watching and their mate was just winding them up.

There was some snarling, and Tracksuit Bottoms was given a sound jostling.

We didn't really want to interrupt. Despite a distinctly spartan theme to the decor, there was a homely fireside thing going on.

"I bet they're all orphans," I whispered, "like the *Pirates of Penzance*."

"Maybe they're the band," my wife replied, then marched up to the bloke she reckoned was the leader, tapped him on the shoulder and asked what time he was on.

The bloke sat bolt upright. "Sorry, darling?" he asked, then nudged his mate, thinking his luck had taken a turn for the better.

"Is it upstairs?" persisted my wife, smiling.

I've seen scenes like this in films about body-snatching aliens where one of their "kind" engages with some unsuspecting natives. The outcome always ends in tears.

The pirate crew must have seen the same films. Realising they had guests and that something much more interesting was happening to them than Nick Berry, they lit new fags and craned their necks for a better view of the action. But they were quickly disappointed.

"The folk music; is it upstairs?" continued my wife, at which point Nick Berry was back on.

"No, no," answered the bloke, "it's right here, dear . . ."

For some reason, he winked several times, which worried me, then he motioned with his hand round the corner into what he called grandly the "VIP lounge" and recommended we make ourselves comfortable.

He watched us over his beer as we surveyed the empty tables, each one

boasting a romantic waxy bottle and candle, then, still holding his pint, mimed playing a fiddle and winked again.

My wife took him at his word and table-hopped for a few minutes.

She always does this, so I know better than to sit down until she's completely happy with her seating arrangement and the view. Then came the all-important question of drinks.

I didn't think for one minute that there was any question of being under threat of physical abuse, but I just couldn't bring myself to go up to the bar, hover behind the regulars and ask for a dry martini.

I said I would think about it and my wife said she would have a glass of red wine.

"Good idea," I said sarcastically. "I spotted a Chateau Margeaux '58 behind the bar."

My wife frowned, deep in thought. "Any decent Australian Cabernet Sauvignon would do," she decided.

Up at the bar, Nick Berry was pointing a gun at the blonde and Tracksuit Bottoms was trying not to look too smug.

I started to ask for a gin and tonic and out popped a pint of Guinness. Self-preservation is a powerful instinct.

When I asked for a glass of red wine, my worst fears about the extent of the cellar were confirmed by the landlord's covert hunt for a corkscrew. I didn't see him find one, but he returned proudly, carrying a tall glass of red wine, his progress followed by five disapproving looks.

These days, the pint of Guinness could quite easily have been for my wife.

Nothing was said, but I could hear my card being marked. It must be ten years since I drank a Guinness and I was feeling like a new man already.

I must have looked like one as well, because my wife's eyebrows were raised as I sat down.

I told her they'd run out of Martini.

Two smiling students had arrived and burrowed their way into the corner. My wife had been chatting to them, but as she took her first sip of the wine her face tied itself into a knot.

Speechless, she began waving her hand over the glass as if she was trying to make it disappear. It didn't take long.

"I'll drink anything," chirped one of the students, so more as an experiment than anything else he got himself a free glass of something volatile resembling red wine.

Apparently, he and his pal had only 53p between them, so they decided to share the wine and I was sent back reluctantly to the bar for a gin and tonic.

It took me three or four attempts to order it and every one of them was monitored by the entire bar.

Things were warming up on the folk scene when I got back. Some fiddlers had arrived and a chap who looked like Merlin produced a harmonica from thin air.

Our son Adam pitched up with his bodhran, laid out the lethal weapons he uses to punish it and began thumping out a rattling beat.

No sooner had he started than the now legendary glass of red wine exploded, confirming its unstable nature.

"Wow," exclaimed one of the students, "some drumming."

I assume someone must have knocked the table, but, as far as we could see, the glass split in two spontaneously.

Evidently, we were in a non-wine-drinking zone. Personally, I was glad to see the end of the wine escapade, but my wife encouraged one of the students to return the broken glass to the bar, forgetting that it had her lipstick mark round the rim.

I didn't think he would come back. I saw the crew up at the bar throwing black looks at him as he handed the landlord the lipstick-smeared glass. I couldn't bear to watch, but he reappeared a few minutes later in one piece with a replacement glass of potentially explosive red wine.

It was too much for the pirates: they cleared out to a man as Blind Pew arrived with his flute and ordered a small sweet sherry.

"It wasn't as good as this last week," shouted Adam over a raucous reel. "There was only me and a one-legged accordion player."

Shame we missed that, really.

Pinkie

IN ITALY, you can always tell when the Vatican is carrying out structural repairs on one of its ancient buildings, the tell-tale scaffolding is jet black and spotless and all the couplings are gold. The scaffolding also has a distinctly perfect air about it, as if it has been arranged and aligned with its environment to give the best possible effect. This is never a happy accident. Every region has its own scaffold inspector, or Direttore artistico dell'impalcatura, and it's their job to ensure only loveliness reigns on the site.

We saw one in action in Assisi after the last earthquake and I remember remarking to my wife that this was my kind of job.

"What, chief titivator?" she asked. "But that's what you do, anyway, isn't it?"

She had a point, but unfortunately the opportunities for titivating were thin on the ground – until recently, when Shawn rebuilt the dyke at the bottom of the garden, an event so utterly splendid and contagious that our driveway and garden have now grown their own little walls and dykes, presenting to visitors and passers-by an apparently seamless experience of granite and countryside, agreeably authentic and charmingly crafted.

Apart from one crucial point, that is, where the dyke at the bottom of the garden finally comes to a rather public end right on the verge of the road. There, the first major task for the chief titivator presented itself. The problem lay with the end stones on top of the dyke: should they, for instance, follow the example of their predecessors and traverse the dyke, or should the last two sit at right angles to the rest?

It was a weighty question made all the weightier by the sheer bulk of these stones which only the mighty Shawn could tease into place.

He tried them in a variety of arrangements until the blood vessels on his forehead stood out and made a map of Australia.

This was titivating by proxy at its finest and for a few moments I knew how Hadrian must have felt, or rather how Hadrian's titivator maximus felt.

Shawn, meanwhile, took a typically philosophical stance as he looked at the end of the dyke, rubbing his stubbled chin. "Makes no odds, anyway," he said thoughtfully, "the boss'll 'av the last word."

Shawn comes from Wiltshire, so if you can imagine that as a scene from the Archers with me sighing in wistful resignation you'll get the idea.

When my wife turned up, she looked at the end of the dyke for about two seconds before declaring that the two end stones should be identical. Then she left. Basically, the chief titivator had been put in his place.

Shawn and I looked at one another silently, trying to work out where we were going to find a pair of identical granite boulders.

"Anyway," I said eventually, "can I leave that one with you, Shawn."

"No problem," he replied heartily, then muttered darkly: "I'll nip round later to the identical-boulder shop."

And so the dyke remained, aesthetically incomplete, until one afternoon last week I decided to take matters into my own hands, literally.

We still had an enormous cairn of huge boulders in the drive, so how difficult could it be, I thought, to find a match for one of the stones at the end of the dyke.

The problem was one of reference. Basically, I would have to remember what the stone in question looked like, or heave it up fifty yards or so to the pile. Which is why I now have about a dozen photos of a boulder on my phone.

The light wasn't that great and it was hard to pick up distinguishing features, but I reckoned I had found my match, so I carried this huge lump of stone down the road to the dyke end.

Getting it up on to the five-foot-high dyke was no mean feat and for the last few inches I had to "chest" it into place, bearing in mind this was the sort of boulder that Shawn would have had for breakfast.

I had just got it roughly on the edge of the dyke when an elderly woman passed, walking a dog.

"Lovely job you're making," she said. I turned and thanked her, trying my best to look suitably bashful when the boulder rolled back in a sneaky counter attack and attempted to smash my right hand to pulp. But I was too quick for it and smirked as I whipped my hand away.

Unfortunately, I left my pinkie behind to take the full brunt of the boulder, which was the equivalent, I imagine, of a small car parking on top of it.

The pain shot up my arm like an electric shock, forcing horrible words from my mouth. Just as well the old woman had moved on, but she looked back so I gave her a crooked smile and a limp wave with my free hand.

I then waited a moment before lifting the boulder free, convinced my pinkie had been crushed beyond recognition. But I couldn't move the stone with one hand.

I had been titivating for less than two minutes and here I was stuck to a dyke by my pinkie, on an open road, like the Dutch boy who stemmed the rising tide.

I gave the boulder another Herculean heave, but it wouldn't budge.

I had my mobile phone, so it crossed my mind to call Shawn; he would have loved to come out and free me, just so he could laugh his head off.

But at last I managed to rock the boulder off the dyke with some of its pals and down they came on to the big toe of my left foot, where they formed a small but significant cairn.

Within half an hour, both the pinkie and the big toe had transformed into two diametrically-opposed throbbing prunes. I was admiring them in the bathroom when my wife turned up with the startling news that some hooligans had been tampering with the end of our dyke.

"Honestly," I fumed, "some people can't leave anything alone."

All in a Good Cause

I MAKE a point of never volunteering for anything, because I know that it's only a matter of time before my wife does it for me. In other words, I do what I'm told. This gives me the comfort of occupying the moral high ground without actually knowing where it is.

In the past, this sort of thing would happen without me even noticing it. One minute I would be asked to hold a dripping paintbrush while my wife washed her hands, and the next there would be a queue of thespians forming to thank me for volunteering to paint their panto set.

After years of finding myself sacrificed to a good cause, I still can't find a way out, but I have at least developed an early warning system, which allows me the fantasy of running away. Its signal is a deceptively innocent-sounding phrase – "It won't take a minute."

If you're my wife, then it really won't take a minute, because that's all the time she needs to involve me. My wife says this is simply a matter of management and delegation. She finds something that needs to be done, which she discovers she can't manage and then delegates to me.

We were on our way home last week from a shopping trip when that fateful phrase reared up and engulfed me like a tidal wave. "Do you mind if we stop and collect some stuff on the way home?"

"Of course; no problem," I said.

Harmless enough, I thought. But then right out of nowhere came: "It won't take a minute."

My wife muttered it as she rummaged in her handbag for an ominous-

sounding piece of paper. These were obviously our directions and the muttering was just her way of saying they would soon belong to me.

As we drove in ever-widening circles towards this "stuff it would just take a minute to collect", I attempted to cheer myself up with the prospect of embarking on a new worthy adventure. But I wondered what this "stuff" would be.

The excitement was killing me. So much so that I could barely concentrate on where I was going. My wife, of course, had excellent directions written on her piece of paper and, although she was holding it upside down, I was obviously the one who had got us lost.

Just to make matters worse, it was raining heavily; but then it has to rain heavily before my wife can take me on one of her quests.

After passing the house we were looking for three times – it seemed to have been built on the wrong side of the road – we decided we had arrived.

"I suppose it depends on where you're coming from," consoled my wife. Then she said it again: "This won't take a minute."

And she was right. Obviously, she now has this delegation business down to a fine art because, about thirty seconds later, she dashed back to the car with a cardboard box under her arm. She was wet, but absolutely delighted.

Apparently, there was a lot more where that came from, far too much to fit into her own tiny car, so she wondered if I could collect the rest at my leisure. Since this would be when I retire, I said I would do it the next day.

Peering into the box, I tried to work out what was so exciting and important about its contents, but it just looked like old junk to me, and there was lots more of it waiting for me to collect.

"I haven't bought this stuff," countered my wife. "It's for the Imperial Cancer Research shop. I said I would collect stuff for them."

It's always nice to know who I'm working for. A few days later, the front passenger seat of my car was covered in maps. The back seat and the boot were groaning with piles of loose-limbed boxes of books and crockery, bulging black refuse bags that you could barely pick up, a rolled-up duvet, an electric blanket, and a sinister gang of soft toys that had been seriously sucked on.

Essentially, I was driving a charity shop, and even although it was all in a good cause, I felt like a rag-and-bone man.

There is something very spooky about sharing an enclosed space with someone else's cast-offs; even more so when they aren't very valuable.

This was everyday flotsam but, at some point, all these things had played an important or, in the case of the reshaped teddy bear with one ear, vital role in their owners' lives.

As I drove around scouting for the next junk donor, I wondered if burglars ever donated their unwanted plunder to charity shops, perhaps as a form of restitution.

At least all of my householders were more than happy for me to divest them of their belongings. Although I did wonder why they couldn't just drive down to the charity shop themselves, since most of them had cars. In fact, some of them had several cars: one had three, including a neat little red sports number.

I had allowed my wife to talk me into this business because she said none of the people could manage to deliver the donations. When I arrived at the Imperial Cancer Research shop, I found out why. It was right next to two other charity shops near a busy junction and a set of traffic lights. I had to make three stops just to empty the boot.

I decided I could live with the black bags on the back seat until I had accumulated enough brass neck to revisit the wrath of my fellow-motorists. The next drop was going to be a titanic effort, and I had that sinking feeling before I even set off.

Needless to say, it was raining heavily, so I took a leaf out of my wife's book and delegated my son Adam to do the donkey work while I guarded the car a couple of hundred yards away round the corner.

It took Adam three trips, but I think he found it a rewarding experience.

"It's all in a good cause," I shouted after him as he snarled his way down a flight of steps with two stuffed black bin-bags in each hand. As the boxes disappeared one by one, I could feel my car breathing a sigh of relief.

Finally, Adam slumped into the passenger seat with a lovely rosy glow on his cheeks. He was now rather pleased with himself because the old lady in the shop was absolutely delighted with such a large and unexpected

donation. He had, of course, dumped everything in the first charity shop he had come to, which was not exactly the plan.

There was nothing else for it: I had to take matters into my own hands and volunteer Adam to go back, explain his mistake, ruin the nice old lady's day and then take everything to the Imperial Cancer Research shop next door.

"It won't take a minute," I said.

Lost

I SAID I would pay for lunch, so of course everyone turned up. It's certainly one way of ensuring a full attendance from your family.

I had also put it about that tardiness of the usual half hour either way variety would not be amusing, so that when I bowled in ten minutes late everyone would be sitting comfortably and waiting to begin.

It worked a treat. Even my wife had beaten me to it, an event of such rarity I reckoned it warranted a front page and the respect and awe accorded to the arrival of Halley's comet.

I came in a bit like Halley's comet myself. Having just negotiated a tricky constellation of business meetings followed by a swift orbit of some large department stores, I was mildly ablaze, leaving behind me a trail that was soon to become very useful.

I was removing my coat and saying hello to everyone when I steered into a big dark thought that went along the lines of me not having any money, or bank cards, or even a wallet, for that matter. Which was, of course, highly improbable since I had felt it in my coat pocket just a few minutes earlier.

It turned out to be my phone, which does a mean impression of a wallet,

until you buy something, of course, and then it's useless, unless you want to phone someone for money.

A rummage through my coat and trouser pockets turned into what is popularly known as a nightmare scenario. In a real nightmare, I would have been naked, or had no trousers on, which for some reason is worse.

Another rummage around my pockets only confirmed those dark, horrible thoughts.

"Honestly," exclaimed one of my sons, "anything to get out of paying for lunch."

But I wasn't listening; I had dived into a zone from which there was no empty-handed return. I snatched up a menu, told my wife what to order for me and said I would be back.

The restaurant was busy and I had the impression the whole place was watching me as I left, but it was probably my imagination. My wife shouted something in a vain attempt to stop me, but I was off, coat flying open, hair all over the place, eyes fixed wide. It was hardly surprising that people started giving me a wide berth.

At this point, I was convinced I would be back in the restaurant within a handful of minutes, wallet and its contents safely restored to my person. I'd probably have to trouble only one shop, namely the last one I was in, and I would get a result.

It was a clothes shop where I'd tried on a pair of shoes. By a stroke of luck, the manager was standing right next to the display where I had been earlier.

"Hello," I said very confidently. "I left my wallet here; can I have it back."

I didn't mean it to come out as if I had just arrived off a boat, but it had the desired effect. That and possibly the fact that I now looked slightly deranged.

The manager looked old enough to be my grandson, but he was very helpful. He made me sit down and re-enact what had happened. In fact, I tried on the same pair of shoes, which I had earlier rejected, and for some reason they now felt perfect.

"So was there a specific reason you didn't like them before?" asked the manager, sniffing a sale.

I made a deal with him – he would give me the wallet and I would buy the shoes. Unfortunately, he couldn't keep up his side of the bargain.

He upturned all the seating and most of the shoes, and broke into quite a sweat while I hovered pensively. You can't really get stuck into rummaging through someone's shop, although I felt like it.

The next shop also drew a blank, and the next, mainly from the assistants who couldn't grasp the concept of someone handing in a wallet they had found in their shop. I left them gawping at one another and ran to the bank, which was close by.

I wasn't prepared for the dense queue at the inquiries desk. It wasn't in my plan. I was meant to get immediate attention and cancel my bank cards and breathe a sigh of relief, but instead I was standing in a queue of people who either appeared as if they were going to make a career out of it or were grasping phrase books. I spent some time standing beside a woman in a wheelchair who smiled up at me a lot and then I left and ran round to the police station.

There was no queue there, just some rather troubled individuals pacing around in the waiting area.

"Was it stolen and, if so, where was it stolen, sir?" asked the girl behind the blast-proof Perspex screen.

I couldn't answer that one, so, while I pondered, she looked me up and down. They must have a nutter scale they use, like some sort of mental scanner. I think I was about to pass it with flying colours.

"I can't rule out the possibility that it was stolen, but I may have just lost it, or even mislaid it," I said.

"Actually, it's not really a wallet as such, although it's definitely missing."

The girl narrowed her eyes at me, looked me up and down again then directed me to lost and found.

The policeman had lost his pen and paper, so I offered him mine, but he vanished for a moment then re-emerged holding a sheet of paper he had picked up from the floor.

"Lost and found," he said, laughing to himself.

In time-honoured policeman fashion, I could have sworn he licked the nib of the pen and suddenly I felt rather comforted. He took down my particulars and then off I went.

"I would check the shop door, sir," he said rather enigmatically as I left. There had been several shop doorways involved, so I was left wondering which one he meant.

At the bank, I was jinxed and knocked over a stand of leaflets and then swept the leaflets off the counter. The girl was very understanding; said it happened all the time.

Three-quarters-of-an-hour later, back in the restaurant, everyone had moved on to their coffee.

"Incidentally," began my wife, "I did try and stop you before you left, but you ran off so I didn't get a chance to tell you that your fly was open."

Not only was it open but I was in serious danger of exposing myself.

"Draughty?" said one of the waitresses as she sailed past.

Still, at least I didn't have to pay the bill, although when my wife settled it she did give me the receipt.

No Smoke with Fire

THE last time my wife decided to stop smoking, the Government should have issued a public health warning. Fortunately, I was the only person in the firing line. Two minutes after she announced she had smoked her last cigarette, I was dragged out on an impromptu walk through the woods. Actually, it was more of a bolt, with my wife constantly in the lead, puffing away furiously on her little white plastic inhaler.

"You'd have to be superhuman to smoke this thing," she declared.

"I thought you'd stopped?" I asked.

"Of course I've stopped; how long has it been now?" she asked, then checked her watch.

"Six minutes, not bad, I can still speak English and I haven't strangled you yet – early days, of course."

Then off we went like vigilantes on the warpath.

She lasted an hour, which, under the circumstances, was quite a feat. Half an hour into our tramp, and three miles from home without a cigarette, she cracked at the thought of being out on a fagless limb.

"Who do we know nearby who could come out in their car with cigarettes?" she demanded, looking worryingly wide-eyed.

Right on cue, a car appeared and she actually considered flagging them down and asking if they could give her a cigarette, but they sped past.

"They didn't look like smokers, anyway," I said.

"Oh, how do smokers look, then?" asked my wife, showing the first signs of a distinct twitch.

"Well, you don't look as if you smoke, for a start," I said, perhaps a little obscurely.

"What if I stood like this?" asked my wife, striking a tarty pose. "Is that better? Can I smoke now?"

I wasn't convinced.

"It's good, don't get me wrong; if you were looking for a part in Moulin Rouge you would definitely be in with a shout."

"You don't think it needs something?" asked my wife, "Like, for instance, a cigarette."

She resumed dragging on her plastic pretend cigarette and then she spotted a van approaching. It was all I could do to stop her waving it down. Fortunately, the blokes in the van took one look and sped on. Either they thought I had kidnapped her and I was mad, or she was mad and I was trying to restrain her.

When she said she was only kidding, I let her go and she ran after the van. The driver must have floored the accelerator because it vanished in seconds leaving my wife shaking her fist at it.

Inconsolable, she turned into Mrs Hyde, a devil woman that I would have to get used to, apparently, since this was actually her real self. I didn't believe a word of it.

"Look, it's only been forty-two minutes since you had a cigarette and

you've been puffing on that thing non-stop; you've probably got nicotine poisoning and it's making you deranged," I said, but none of this was going anywhere near my wife's brain.

"Which way are we going?" she muttered, grabbing my arm. "Are we heading in the right direction for the house? Is it much farther? What do you think? How long will it be before we're home?"

You would have thought we were refugees on the run.

Suddenly, we were taking shortcuts across fields and ditches, over dykes and a burn that turned out to be just two or three feet too wide to jump, which was disappointing, and surprisingly cold.

Back home, my wife didn't waste any time in lighting up. She walked around the garden hugging herself as if she had survived one of the most frightening experiences of her life.

"It's amazing to think that there was a time when people didn't smoke," I mused.

"Who are we talking about here? Tudors?" she shouted, "Hang on, you've got a point; I think I'll stop smoking right now because Henry VIII never lit up."

"What about Thomas à Becket?" she ranted. "Again, no fags; I think you're on to something. In fact, they should put that on cigarette packets, if there's any room left – 'famous historical figures never smoked, so why should you'".

So when you read this column, bear in mind that my wife hasn't had a cigarette for seventeen days. Not only that, but we've been living in the same house all that time. Admittedly, my wife's studio is at the bottom of the garden in a place where only the adjoining neighbour can hear you scream, but so far there are no visible signs of damage. I keep thinking my wife must have some secret whipping boy that's getting a regular thrashing on the sly. There's a punch-ball in her studio, so maybe that's getting a pounding.

The first few days were the worst, which was hardly surprising. When I collected her from the hypnotherapist, I asked how she felt.

"Fantastic," she declared. "Never felt better; give us a fag."

Then she covered her mouth as if the word fag had popped out of nowhere of its own accord.

Personally, I had thought it would be easy after the hypnotherapy, as if somehow my wife had been programmed to forget she had ever smoked, but where I got that from I have no idea. Obviously it arrived along with the non-smoking Tudors and all those sensible people who don't look like smokers.

Telling my wife on Day Three that I had a good tip for her was also not a brainwave. Nor was telling her I could smell smoke when it turned out the neighbours were having a barbecue. Worse still, informing her that she looked younger after a week and thus implying she looked old when she smoked just seven days earlier was actually mental.

So apart from a little fruity friction, it has been easy this time round. When people ask how she's getting on, I tell them I'm still in one piece, and that's all they need to know, really. The dangerous devil woman I was promised and grew to dread has failed to appear so far. Since there is no smoke without fire, she may have gone for good.

Opra Buffers

WITH just seconds to spare before the orchestra launched into the overture for the opera I dropped into my seat. I assumed the position for lift-off and had a squint around at my fellow travellers.

Some operas are like long-haul flights and all sorts of things can happen along the way so it's good to know who's likely to block the exit if there's an emergency.

I sat there wearing my normal face of expectation, which amounts to a faint smile of optimism, nothing too enthusiastic, there was plenty of time for rapture.

A few minutes later the conductor still hadn't appeared and the orchestra was still warming up, trumpets playing tricky sequences, a flute winding its way up to the balcony, the timpanis rolling like thunder.

Then someone stood up sharply behind me, a woman and something she was wearing wiped the back of my head.

"Where the heck is he?" she demanded.

I was thinking the same thing, but jumping up and saying as much wasn't going to make the conductor speed up his ablutions.

"Sit doon, he'll be here ony minute!' growled an elderly bloke.

"Well he better be because he'll never find the bar," replied the woman, turning round again and brushing my hair with her dress or her coat. I was bathed in the scent of Lily of the Valley which I have to say was quite pleasant.

"This is just typical," continued the woman who was now getting more anxious by the second.

I assumed she was looking for someone else other than the conductor as people were still arriving and making their way to their seats. Baffled, I checked my watch and remembered I had deliberately put it ten minutes fast so I would be on time for the opera.

Sighing, I picked up the programme to read it but discovered the grey text had been cleverly printed in a point size specially designed to be viewed under a microscope so I put it back down again, meanwhile the woman behind had now been joined by a different elderly bloke and they were both busy scanning the stalls for their missing pal.

"It's nae as if he blends in at the best of times," reflected the bloke, "nae wi that heid o hair onywy."

"It's like a flippin parakeet nestin on his napper," agreed the first bloke.

"How could it be a parakeet?" demanded his pal, "it's hardly multi-coloured, it's pure white, possibly silvery white."

"Fair comment, fair comment, it's mair yer cockatoo right enough, a 6-foot-three-inch skinny mannie wi a cockatoo on his heid!" replied the first bloke with some glee.

"Aye cockatoo's good, very descriptive, accurate and straight to the point," agreed his mate, "but there's nae sign o the cockatoo it has to be said."

"Do you mind!" interrupted the woman, "he could be around here and listening to us, anyway you'd think we were out birdwatching!"

"That's the kind of thing that would stick, cockatoo, you'll have to watch that, it might slip oot after a few nippy sweeties at the interval," mused bloke one.

"Actually there are two intervals," corrected the woman.

"Smashin!" chorused several voices.

Suddenly a new woman joined them.

"I feel terrible about this," she began, "when I put him in the lift I just expected him to be still in it when we got to the bottom of the stairs. You don't think he's still going up and down in that lift do you?"

"Well if he is, he'll miss the show," said one of the blokes with some confidence.

"What's this opera aboot anyway?" asked another, "I've never seen this one."

"It's got a fat bloke instead of a fat wifie, that's a ye need to ken," advised one of the men. "And it's got nae tunes."

"Nae tunes!" chimed everyone.

"Nae even one?" asked the woman who was still standing up behind me occasionally brushing the back of my head.

"Oh there he goes!" declared another bloke loudly and there was an audible gasp of excitement.

"Sorry, stand down, that was a real cockatoo," he continued.

There followed a stark silence broken by some stifled giggles.

"Well hopefully he'll turn up in the bar," said the woman.

"I reckon he's already in the bar," muttered one of the blokes.

A light cracked open on stage and above our heads a whirring started.

"Oh we're off, chocks away!" announced one of the blokes.

But still there was no conductor. Instead most of the stalls audience including my anonymous friends behind me contented themselves by trying to locate the source of the loud whirring noise. It sounded like a fan because it was a fan, stuck in the back of the big projector hanging directly above our heads.

"It's comin from that flippin projector!" declared the first bloke who by

this time had established himself as the brains of the group. His pal was obviously the wit.

"Well it's nae somebody hooverin in the dress circle is it!" he said.

"I canna hear a thing," said another, "fit is it yer hearin?"

"A loud whirrin!"

"A whippit?"

By this time several people had tuned in and although laughter was being held under control, shoulders were beginning to bob and people were turning round to catch a glimpse of the alternative show.

"It's a big place this is it?" said one of the blokes.

"Bigger than last month you mean?" replied his mate.

"Big enough to hide a six-foot-three-inch cockatoo onywy!" laughed another.

"At's nae him wi the baton is it?" he continued.

The conductor had appeared in all his six-foot-three-inch glory complete with a head of shocking silvery hair.

"Blow me!" exclaimed one the blokes, "it's the cockatoo himsel, now we'll see some action!"

As the overture started the curtain rose revealing a large, fat man lying on a bed.

"Which een's the big fat bloke?" someone asked in a stage whisper.

As Emily Dickinson once wrote, "The show is not the show, but they that go".

Some operas are like long-haul flights and all sorts of things happen.

Seaside Home

WE WERE a happy band, bonded and multiplied by mystery. There was a blonde woman up front who seemed to have a map. I never actually saw this map, but she certainly had some papers, which she consulted and then pointed convincingly, so within minutes we were all following her like sheep.

"It's the blonde leading the blind," quipped my wife a little too loudly, at which the blonde halted abruptly in mid-stride while my wife and I glanced around to see who had made such an ungracious remark.

But the blonde had a fresh scent and she was off very optimistically up a narrow lane, which turned out to be the path to someone's redundant outside toilet. It had an old sign on the door which read "Poop Deck".

"Very droll," announced the blonde dryly, and then of course we realised we were stuck.

The tight lanes that wove around the little seaside cottages were never designed to hold more than two determined house-hunters at a time.

Twelve was a squeeze and since there was no room to turn without incurring a certain intimacy, we had to reverse our way out.

This type of situation is a litmus test of character.

Consequently, we broke neatly into three groups: the people who were laughing, the people who weren't and the person who thought it would be appropriate to take photographs, namely myself.

"What's that for?" asked my wife, nodding at the camera as we squeezed our way out like Siamese twins.

"I'm making a photographic record of our expedition," I explained, "so we can find our way back to reality."

"Good idea," agreed the bloke in front and promptly produced a camera from a bag.

We had all been given the same clues by the solicitor's office and we had listened with varying degrees of comprehension – in my case, none. After all, how difficult could it be to find a cute whitewashed cottage with a big For Sale sign outside it?

This highly-desirable, upgraded fisherman's cottage was also numbered and it was in the middle of a tiny clutch of ancient seaside houses with the North Sea on one side and the north of Scotland on the other.

On reflection, it would have been a lot easier if the cottages hadn't been numbered at random and if most of them hadn't been cute and whitewashed.

After five minutes walking up and down the chilly, brine-scolded hamlet, my wife and I came to the conclusion that every house owner had obviously been give a welcome pack of shells, some old rope, the remains of a creel and were told to pick a number between one and 100 and stick it on their door.

Just to be really awkward, some rebels had gone for romantic-sounding names instead, so sandwiched, for instance, between numbers sixty-seven and eighty-five was The Auld Craw's Nest. It also didn't help matters that all the cottage owners were at home in Surrey. So apart from a few bad-tempered seagulls, the place looked deserted.

After going round in a complete circle, I stopped and shouted: "Come in, number ninety-eight," then, hopefully, I added "ninety-seven, ninety-nine . . . any number?"

At first there was nothing, just the dull echo of a lonely mad bingo caller playing to 100 shuttered holiday homes. But then people started appearing tentatively from the lanes like shipwreck survivors who had been in hiding.

"I hope they don't think we've come to rescue them," said my wife.

At first we all just passed one another in silence like ships in the afternoon, wary of joining forces in case we gave the prize away.

Then we noticed a couple were following us, so we tried to shake them off

by darting down a lane, but they were quicker than we thought and at the next turning they were still on our heels so we stopped.

As the couple approached, we told them laughingly that they were wasting their time following us because we had no idea where we were going, either.

They stared at us nervously as they passed, giving us a comfortably wide berth before hurrying across the road and disappearing into one of the cottages.

"Time wasters," snapped my wife.

"Excuse me," said a bloke suddenly behind us, "do you know where number ninety-eight might be?"

He had a wife and two children with him who looked as if they had been dragged all the way from Edinburgh, so feeling sorry for them we teamed up and within minutes our numbers had doubled.

I quite like team sports but my wife prefers flying solo, so when she spotted the cottage she kept it quiet until one of the kids shouted: "Look, it's not white, it's cream."

Obviously it had been touched up for the schedule to make it even more difficult to find.

There was a woman standing casually in the doorway greeting everyone.

"I've just come outside for a heat," she laughed as we passed her.

Inside, it was like being in a popular National Trust property that had been lovingly restored. Even although it was packed with people, we were awed by the plaintive beauty of the interior, with its authentic features and original wooden floor that almost made my wife faint with delight.

"There's a sea view from that window," said the woman from the doorway who turned out be from the solicitor's office. "More of a skylight than a window, I suppose," she continued.

Five of us tried to squeeze our heads together around the tiny skylight to scrape an inch or so of the view, which as it turned out was, indeed, very sea-like.

As we left, we looked back at the cottage as if it was an old friend we knew we would never see again. There was a detached villa a few miles away that was for sale and if we hurried we would just catch the last viewing for the afternoon.

"If they served coffee, it would be a perfect day out," observed my wife.
"And perhaps the odd jam scone," I added wistfully.

The Joyrider

RATHER than think the worst when she discovered her car had vanished, my wife concocted a lovely little fantasy involving her father going for a spontaneous joyride. Even although he has no history of joyriding or car-jacking – that we know of – and is comfortably in his mid-seventies, my father-in-law came up as the number-one suspect.

Ripping through the countryside at a bunnet-rattling twenty mph, he had probably burned an iridescent trail across the parish that would be the talk of the post office queue for months. It was an open and shut case. Even when my wife spotted her little blue car parked rather nervously at the bottom of the road, fifty yards from her parents' house, she decided it was probably still the work of her father. Perhaps he had borrowed it, she reasoned, to visit a neighbour down the road, and she hurried into the house to confirm her suspicions.

"Joyriding," shouted her father, blasting his pipe across the living-room.

Apparently, he was not amused by the accusation. In fact, he was visibly bemused and decidedly disturbed by the fact that my wife's innocent-looking car had been the source of so much local drama and near disaster.

The dust had now settled but there was still time for a reporter to turn up and transform the incident into a front-page headline – "Nobody hurt in driverless car incident".

My wife had to sit down to hear this one, particularly since it was obviously all her fault, even although she was somewhere else at the time.

Because it was such a nice afternoon, she had left her car parked outside her parents' house and walked the mile or so into the village centre to do some errands.

It was a very pleasant walk; my wife had a spring in her step because the sun was shining; flowers were in bloom, and the birds were in full song. She laughed at other people in their cars as she revelled in the tranquil fresh air.

By the time she reached the shops, she felt thoroughly uplifted and at one with the world, but while she was browsing blithely round the charity shops her car was stealthily lurching into life and was about to make a clean *brake* of it.

Had my father-in-law passed his front-room window at that very moment, he would have been surprised to see the tiny car sliding silently backwards down the hill towards the newly built wall of an elderly couple who had moved in recently.

Since the old gentleman in question was pottering happily around in his front garden just behind that wall, he was about to get a bulls-eye view.

Fortunately, as the car trundled towards the wall it had a last-minute change of heart. All the same, it must have been a trouser-changing moment for the elderly gentleman as he glanced up from his gardening to see an unmanned vehicle reversing steadily into his property and then, at the very moment of impending impact, turning sharply away.

He was rendered speechless at the time, but had a few words to say on the subject when my wife turned up to apologise.

As you can imagine, she was absolutely shocked and horrified at the idea of almost having a car accident while she was buying someone's unwanted 1970s wedding presents.

In her defence, she insisted that she had fully engaged the handbrake when she parked the car and never for one moment imagined that it might turn into such a dangerous missile.

She went on to explain how it had been in the garage the day before and although it was booked in for some work, they assured her it was safe to drive.

Obviously, as the old chap pointed out, it wasn't safe to park.

Although it was now sitting on a perfectly flat road, he wasn't taking any chances and had wedged a brick firmly behind one of the back wheels.

My wife apologised again and congratulated him on his ingenuity, then asked if she could keep the brick – in case she needed to park later. She was planning on going to the bank and it was on quite a steep hill.

"I think he thought I was a bit of a loony," she reflected later as she recounted the horror story. "He gave me a such funny look."

"Really," I sympathised. "There's just no pleasing some people."

I was just happy I wasn't there when her father's pipe blew across the room, even metaphorically. I was even happier I wasn't around a few weeks later when my wife tried to put things right with the brick man.

Probably because she spent so many years as a pedestrian, my wife fully appreciates the value of a friendly lift in the rain. She'll often eye up complete strangers caught in a downpour and suggest we stop and give them a lift. Unfortunately, at this point, I'm always overcome by temporary deafness.

However, since she was on her own when she spotted the brick man and his wife struggling home through a gale-force rainstorm with only a shredded brolly between them, she felt it was the ideal opportunity to make amends.

Unfortunately, the soaked couple were on the other side of the road, so my wife sounded her horn as she passed them. They stopped and looked back as she drove on and my wife was happy she had attracted their attention.

But by the time she had turned, the brick man's wife had already crossed the road with her brolly, leaving her husband to the mercy of the elements and, more important, my wife.

When she stopped and asked if he lived in such and such an avenue, he motioned ahead through the driving rain, thinking my wife was lost and asking for directions. He was obviously getting wetter by the second, so my wife decided there was no time to waste. She threw open the passenger door and told him to jump in, but he just stepped back and shouted something to his wife. It might have been "help".

Undeterred, my wife persisted, saying that she knew where he lived and

told him again to hop in without delay because she was going the same way, even although she was now pointing in the opposite direction.

He looked at her wide-eyed with disbelief, and peered into the car. For a moment, my wife thought she had him, but convinced he was either being picked up by a desperate woman half his age or kidnapped, he legged it across the road, throwing worried glances over his shoulder.

When my wife passed the couple again, she slowed down and saw brick man pointing her out to his bedraggled wife, so she thought she'd better leave them to it and drove on.

"It was such a shame," said my wife later. "They looked so wet and miserable, but the poor chap obviously didn't recognise me."

But I reckon he did recognise her and the car. The brick on the back seat was probably a giveaway.

Scotch Awa

FOR some reason, I got it into my head that I was a whisky expert, even although I hadn't touched the stuff in earnest for about twenty years. But there was a whisky challenge going on up at the bar that was proving rather too much of a challenge and it was annoying me.

"I'll sort this out," I announced to everyone, and they immediately started laughing.

My wife, however, assumed that I was going to stop a fight and that I was going to come back with a black eye, so she tried to stop me.

"Don't be so stupid," she shouted, "you'll only get hurt."

Everyone now stopped laughing to embrace the complete lunacy of the moment, then burst out laughing again even louder.

My wife was horrified at our so-called friends' cold-heartedness, particularly our two sons, who were encouraging me to "go for it" with unfettered enthusiasm.

"Right, well, I'm coming with you," she declared, picking up her bag which, on an average day, could floor an ox.

"It's the whisky challenge," I explained. "I'm going to win it."

Gales of laughter swept me off through the crowd and up to the bar.

I gave everyone back at our table a wave, but they were either still laughing or pretending not to know me – which I thought was a little shortsighted, considering I was about to become the bearer of free whisky.

Along the bar, there was a meeting of international boozers in full swing. Music and alcohol being the two languages that cross all borders, the place was bouncing in perfect time to a roaring folk band and the cross-rhythm clink of beer bottles.

I muscled my way between a group of excitable Frenchmen and a stout trio of kilted English Yeomen and tried to attract the attention of one of the barmaids. Even although I could see my reflection in a nearby mirror, I had somehow become invisible.

This gave me enough time to have second and third thoughts about my super powers of whisky detection. Back at the table it had all seemed so simple. Faced with two glasses of blended whisky, I would have to tell which one was Grouse and which one Bell's.

No problem, I thought. Not only that, but I could do it without tasting or smelling either of them, and told everyone as much.

Lying on the counter behind the bar, about six feet away, I could see my prey – two trays full of whiskies.

A barmaid caught me eyeing them up. "It's not easy," she said, folding her arms.

"Easier than you think," I replied, leaning over the bar for a closer look.

The barmaid laughed and turned to get two glasses of whisky for me to taste.

"It's all right," I said casually, "I'll do it from here."

"I've seen it all now," said one of the kilted Yeomen, nudging his beer-swigging mates. "Bloomin' Scots and their whisky."

The Frenchmen had also quietened down and were peering at me intently up the bar. This was just the kind of pressure I needed – the audience kind.

As the barmaid hovered between the two trays, waiting for my answer, I paused deep in thought, just for dramatic effect, because to me the difference was blatantly obvious. I've seen enough Grouse poured over the years to know that it's a slightly more golden colour than Bell's.

Anyway, that's what I had convinced myself and there was a fifty-fifty chance I would be right.

But I wasn't about to go public with my secret formula, so I asked the barmaid to come over so I could tell her quietly that the tray on my left was the Grouse one.

The free whiskies aside, it was worth it just to see the look on everyone's faces, particularly when I confessed that I never touched the stuff.

"Typical Scot," shouted my Yeoman mate, "anything but buy a round."

I boogied back to our table and laid the free whiskies down for everyone to help themselves, but they were too stunned to move.

Nothing, I thought, could top that for an evening's entertainment, until my wife announced that since we were still celebrating her birthday, we were off to gatecrash the ceilidh round the corner.

I couldn't understand why we just couldn't pay to get in, but my wife reckoned that was rich, coming from Mr Free Whisky.

She had a point and basically I tagged along in the hope that there might be another whisky challenge. But when we got to the ceilidh, it looked like a wasted journey.

A glowering, bald bouncer was blocking the entire doorway and I turned back immediately. But my wife marched straight up to him, shook his hand and informed him we were the surprise band.

He frowned all over us; obviously thinking we were a touch light on the instrument front.

At this point, the folk band from the pub turned up armed with fiddles and guitars and my wife shouted: "Ah, good, our roadies; better late than never."

It's a long time since I've blagged my way into a dance, but believe me it's

far more exciting than paying. In fact, I was so excited I had to run a gauntlet of tartan to the loo.

"He's a famous whisky expert, but he gets nervous before a gig," my wife confided to the bouncer, who looked as if he couldn't have cared less.

But on the way back from the Gents, he collared me and rather nervously asked for my top malt recommendation.

"The MacStanley," I told him confidentially, and he made a mental note.

Inside the hall, utter bedlam was in full swing, which is a fair translation of the word ceilidh. Outside in the street, you would never have believed that through the wall there were about 400 people trying to untangle themselves from a loosely choreographed scrum, all lit eerily by overhead ultraviolet lamps.

It was a frightening sight. Everyone had fantastic tans and dazzling dentures and if you were wearing white, you stood out like a human flare and lit up all your mates.

Of course, half the people had fantastic tans and dazzling dentures because they were American.

At first, I couldn't see our party of gatecrashers and wondered if they had been rumbled.

There was a lunatic in a hooded jacket dancing like Johnny Rotten from the Sex Pistols between tables of speechless onlookers. So I watched him for a while, laughing to myself, until I realised it was our son Richard and my wife was behind him bent double with hysteria.

She decided he needed some of that traditional Scottish choreography, so she lured him into the bustling fray on the dance floor so they could be cajoled, abused and nagged at in several languages for not knowing their Dashing White Sergeant from their Gay Gordons.

"Now can we go home?" I asked when they returned battle-crazed and wounded.

"That was great," shouted my wife, "it was like going round the world in an eightsome reel."

Aye, there's nothing like a faux-Scots night out to get your dander up.

The Birdman of Tuscany

THERE was a bald, skinny, German bloke in the shop testing a bullwhip – not the sort of thing you see every day, so I thought I would hang around and see how he got on.

This shop on the south side of San Gimignano, Tuscany, is the sort of place your average Italian gent must go when the compulsion to buy a crossbow or a samurai sword becomes irresistible.

The long, narrow entrance-way is lined on either side by glass cases stuffed with the sort of lethal gleaming steel that makes me shudder from scar to scar. Maybe the knives, axes and swords are magnetised because, every time I passed by, there was always a posse of men with big moustaches holding solemn conversations in front of the place.

Mostly they were tourists who had managed to give their wives the slip in one of the leather handbag or shoe shops that stampede the length of the street.

The funny thing is, at the end of the gruesome parade of razor-sharp weaponry, the shop disarms itself and transforms, as if an evil spell had been lifted, into a charming Tuscan pottery boutique – a sort of Trojan Horse effect in reverse.

The bald, skinny, German bloke – big moustache, of course, and little round specs – was standing, feet spread apart, cracking his whip surrounded by shelves full of teapots, biscuit barrels and plates, all decorated with pretty flowers and gentle rustic scenes.

He didn't seem to mind, but the huddle of French women who were

shopping for souvenirs made up for it with a catalogue of scowls and alarms.

At every air-splitting crack, they leapt with fright and fanned themselves with their guidebooks, like Baroque ladies.

The manager bowled up to count the casualties and persuaded Billy Bullwhip out to a balcony where he could kill some flies quite easily at fifteen or so paces.

For a moment, I thought the manager was going to push the whipmeister off the balcony, but he was just giving him a manly pat on the back and saying something like "Go on, my son" in Italian.

I hadn't noticed the three German boys standing in an ordered line behind a display of huge garden pots. They had done an admirable job making themselves invisible until dad called them over to take a reluctant crack at the whip while he smoked his pipe.

I left them to it, fairly convinced I'd seen it all, but I hadn't. I had passed this shop shuddering to myself many times, but for some reason it occurred to me that it might be just the sort of place to sell bird-callers.

This probably sounds as peculiar as buying a bullwhip and, in the right hands, a bird-caller can be just as lethal, but not mine. My interest is purely aesthetic.

The bird-callers I've bought in Provence are a kinky, tactile mix of wood, metal and rubber. Some of the callers have to be blown, while others can be squeezed or struck gently to produce their mellifluous sound. If you get the balance right, you can impersonate an entire Luberon hillside.

I had never seen any bird-callers in Tuscany until three of them caught my attention in the window of the Samurai sword shop.

"You're on your own there, I'm afraid," said my wife. Then she wished me luck.

This was a blow; there were still at least 300 handbags left in San Gimignano for my wife to show me.

Fortunately, the girl behind the counter spoke English, or at least I think that's what she said. When I told her I'd like to buy the three bird-callers in the window, she gazed at me as if I had hypnotised her. Her mouth fell open

displaying a dazzling set of perfect white teeth, but one crack of the whip and she was back with me again.

She was still looking puzzled, so I gave her my repertoire of bird impressions. I opened with a wood pigeon – always an easy one – then an owl. Probably too similar, I thought, so I broke into a medley of ducks and, for a grand finale, I did a cuckoo, which came out suspiciously like a wood pigeon.

By the look on her face, she had never heard a bird in her life and she looked round at her colleagues, shrugging her shoulders for help, but they had eyes only for the Family Bullwhip, who were really hitting their stride out on the balcony.

Suddenly, the French ladies bustled past me in a Sacre Bleu, bound for the safety of the thronging street. I think my cuckoo impression had been the last straw.

In their wake, I managed to coerce the assistant along the entrance-way, where I pointed at the bird-callers. She stared at them for a moment until a look of recognition brightened her face; then she unlocked the cabinet and pulled them out.

Delighted beyond words, I took the first one from her and gave it a tentative blow, expecting some beautiful sound to fly out the other end. But nothing happened, so I squeezed the rubber bulb, and still it refused to even squeak. "Dud," I said, and took the next one from the girl, who was staring at me in rapt fascination.

This one was far more intricate and looked very promising, probably some fantastic exotic duck, I thought. But again, no amount of blowing or squeezing would bring it to life. No wonder the assistant had been reluctant to sell them.

I had one left, on which I now placed all my hopes. It certainly looked the most unusual of the three, with a long silver pipe at one end that drooped like a beak. I had saved the best till last. I smiled to myself, thinking this is the one; just wait until the assistant hears this, she'll probably break into spontaneous applause and scream for an encore.

I took a deep breath and gave it my best shot. In fact, I almost went blue in the face trying to get a sound out of this thing, but I might as well have been trying to inflate a four by two.

Even giving it a good thump against the glass cabinet produced absolutely nothing. It was as dead as a dodo.

Completely crestfallen and out of breath, I thanked the baffled assistant for her help and turned to find the skinny German bloke and his three sons standing behind me, each one of them armed with a feebly wrapped bullwhip.

"Zey are not for blowing," intoned the German behind his pipe. "Zey are for wine bottles – American Freepours, you call them."

The assistant grinned broadly, wiped her brow and said a prayer. I thanked my German friend for clearing up my little mystery and we shook hands.

"No, thank you," he said with a wry smile.

Down the entrance-way, I could see the entire staff of the shop jockeying for position to get a butchers at the weird birdman.

And to think I could have a bought a bullwhip as long as a mini-bus.

Nutcase

WHILE I was out minding my own jolly business, there had been a bit of a trauma, which had turned into a roaring drama, or maybe it was the other way round. The outcome was the same: a first-class, full-steam-ahead, fun for all the family "drauma".

"So what part of that story was amusing?" asked my wife, wiping the smile from my face. "It's not funny at all; it's a disaster."

So now it was a disastrous "drauma". Obviously, things couldn't get much worse. They could, however, get more complicated.

The situation so far involved my wife's aunt and a missing suitcase. Somehow, the two had become mysteriously parted from one another at

the bus station. However, it wasn't all doom, "drauma" and disaster.

Once all the other carefree passengers were in receipt of their luggage, there was one solitary suitcase left looking decidedly sheepish, but nonetheless hopeful of a happy outcome.

"Please take me home," it pleaded and, if it had been me, I would have. Better some stranger's underwear than a weekend going commando.

But then I'm not my wife's aunt. She has a more discerning nature and a more stylish wardrobe, some of which she had packed into her suitcase.

Presumably as a precaution against the case going AWOL, she had then listed the contents of the case. But since the list was inside the case, this wasn't really much of a master plan.

So my wife's aunt wasn't completely sure what was in her case, but she had absolutely no idea what was in the very similar, but slightly smaller, black case she had been presented with by the bus driver.

One thing was certain, it would not contain the outfit she had picked out for the family celebration she would be attending the following afternoon, or her make-up, and various tools of the trade. She was in effect a woman shipwrecked with nothing but the clothes she was standing up in.

Personally, I would have taken advantage of the situation, headed straight for the nearest shop and kitted myself out, but I was assured this would have been an expedition spanning several weeks.

So it was the wrong case or nothing and in the ensuing "drauma" my wife and aunt decided the best course of action was do nothing. The case was handed over to a bus company official called, rather improbably, Levi Strauss, or Something Wrangler. According to my wife, it was a name like a pair of jeans.

Actually, it was Lee Cooper, so she was on the right track.

"Funny how it was all to do with clothes," she mused.

Just to confuse him, Mr Cooper was given half a dozen different contact telephone numbers. Hopefully, the person who had taken my wife's aunt's case would realise the error of his or her ways, return it to the bus station and pick up the correct case.

My wife then drove her deeply troubled car-phobic aunt sixteen miles very slowly to her father's house, where she would quite possibly spend the entire

weekend dressed for a long bus journey. The dire prospect of this forced them to stop and buy emergency undergarments – not the usual standard, of course, this being the designer-free rural provinces, but needs must.

Apparently, the sales assistant in the shop got the whole story and was suitably traumatised. She promised to keep an eye out for the suitcase, even although it was probably being riffled through twenty miles away in the opposite direction.

And that was that. After reliving the events, my wife decided we should go for a walk to clear our heads and of course the moment we left the house a man phoned to explain how his sister-in-law had lifted the wrong case at the bus station.

However, they had now returned it and collected the right one. He was very apologetic and sounded genuinely concerned by the "drauma" such a mistake must have caused.

Meanwhile, all through our walk, my wife fretted over what her aunt was going to wear for the party the following day. By the time we got back to the house and discovered the message, Lee Cooper had finished his shift and locked my wife's aunt's case in his office. No one knew when, or even if, he would be back. When my wife phoned her aunt to break the good and not so good news, she was surprisingly breezy about the whole business, about two drams worth.

Anyway, everything was hunky-dory because, apparently, the matter was resolved. The same man who phoned us had called her shortly afterwards, and promised to deliver her case that very evening. It was the least he could do, he said.

Nothing my wife said could convince her aunt that the case was now locked up for the night, if not the entire weekend. Fearing that my head was about to blow up, I called the man with the suitcase-blind sister-in-law and asked him how he intended springing the case in question from a locked room and transporting it sixteen miles to my wife's aunt.

Again, he was full of apologies, basically because when he promised to deliver the case it had slipped his mind that as the result of a recent accident he wasn't allowed to drive, not that it mattered because he didn't actually own a car in the first place.

I recommended that he call my father-in-law with the same story, which he did, but first he decided to check out my credentials, as if I might be some random suitcase thief.

"Does the name **Roddy** mean anything to you?" he asked my father-in-law.

THE following morning, at the crack of nine, I made the first of three round trips to town. At the bus station, Lee Cooper proved elusive, and I began to fear the worst until I realised I was asking for Levi Strauss. It must have been the "drauma"; it has a disturbing effect on the mind.

I met Lee Cooper by fluke as he unlocked his office and for a fleeting moment I saw what I assumed was the legendary suitcase. I explained how I had come to collect it and he duly whipped a card from his pocket, held it up under his nose like a winning poker hand and asked for a name. Which I gave him.

"Wrong," he exclaimed, "better luck next time, mate."

At first, I thought he was joking, but when he started closing the office door I asked if I could phone a friend.

"OK," he said, "one more go; I'll give you a clue, the first letter was the same."

I racked my brains until I came up with my father-in-law's name.

The case had little wheels, but it was still quite heavy, not heavy enough, though, to hit anyone with and cause a genuine "drauma".

Glasgow Smiles Better

THE deal was, I would spend a quarter of an hour in the second-hand-record shop while my wife and my son Adam relaxed in the café a few doors down the lane, then we would take the underground into the centre of Glasgow for some serious retail therapy.

I was rubbing my hands with glee as I slipped into a warm, welcoming pool of old jazz vinyl, confident I could stretch that fifteen minutes to twenty, maybe even half an hour at a push. But after just ten wonderful minutes, I had fulfilled my mission and was back outside clutching my bulging carrier bag.

My wife would have been impressed if I could have found her. Not only had she and my son vanished, but they had taken the café with them. I had been so focused on the record shop that I hadn't given the café a second thought.

It was there the last time we had been in the lane, right next to the antique-furniture restorer, but now it had been cunningly replaced by a big metal lock-up door.

For one crazy moment, I thought about banging on it, just in case my wife and son were being held captive inside, but instead I decided to have a rational stroll up the lane to the street, keeping that initial frantic notion within easy reach, of course.

Half-way down the street, I was relieved to find a very smart café bar and expected to find my wife and son waving at me inside, but it was almost empty and the girl with the dark-green hair behind the brushed-aluminium counter had never heard of the other café down the lane.

I was laughing, but the back of my neck was beginning to prickle with panic.

Back in the lane, I was relieved to find the second-hand-record shop where I had left it, right next to the second-hand bookshop, which I made a mental note to visit once I'd got this business with the café sorted out.

The antique-furniture restorer was sitting in his window and looked in need of some restoration, so I didn't disturb him. In fact, I think he had dozed off over a drawer. The lock-up door looked severely locked up, so I thought I would check round the back, maybe climb in through a window and rescue anyone who needed rescuing.

But just round the corner, my wife and son were sitting laughing hysterically under some kind of bamboo lean-to arrangement that overlooked the back drying green of a tenement.

Apparently, this was the café, or at least the alfresco area of the café. I didn't venture inside but, from the bead-fringed doorway, it looked like a cross between a harem and the lair of a gang of burglars.

A handwritten notice near the door warned customers to have the exact change at the ready.

I couldn't get much sense out of my wife and son, apart from the fact that they couldn't understand the menu. It was written in a language known only to free-thinking bohemians who have trekked the ancient spice routes in hand-woven grass ponchos, so they were drinking "espresso type" coffee and my son had ordered a bowl of strawberry porridge, even although it was 1.30pm.

Suddenly, I remembered I needed the toilet, but my wife couldn't recommend the one in the café – not unless I had been vaccinated recently against tropical diseases. Ten minutes later, I bailed out for the second-hand bookshop and left them still laughing over their "espresso type" coffees in anxious anticipation of the strawberry porridge.

Sometimes I worry about my wife: an espresso coffee, even a fake one, has the same effect on her as a double brandy. Which might explain why she drinks so much of the stuff.

The bookshop, like all bookshops, was a sanctuary of soothing sanity. Well, almost. A bloke with a long pigtail had brought his cat with him for a browse and it was hissing at people from his shoulder.

I gave it a wide berth as I picked my way carefully across the shop. There were more books on the floor than there were on the shelves, but this just made rummaging more three-dimensional.

I spotted a hardback Tintin book within minutes and that was my search officially over. I dusted it down and held it up for inspection. It turned out be a 1959 first edition of *Red Rackham's Treasure* – price four quid. "Party!" I thought to myself as I joined the queue at the counter, which was really a huge desk weighed down by several hundred old books.

Behind it hunched an even older white-haired gentleman who looked like he could have been the next Doctor Who. He was using a magnifying glass to check the prices of everyone's books.

He held mine up and peered at it, showing me a giant eye through the magnifying glass.

"Ah, *Tintin and the Adventure of Red Rackham's Treasure*, a modern classic," he said rather loudly.

The woman before me had bought a leather-bound edition of Herodotus and I'm sure she curled her lip up in disgust when she heard this. I didn't care; I've read Herodotus and there are no illustrations.

BY THIS time, I was so desperate for the toilet that it was fast becoming life threatening, so I asked the Doctor if there was a loo on the premises.

He smiled and said that he wasn't sure if it was ready. I assured him that I would take it as I found it and he pointed to a door at the end of the shop.

On the way there, I was stopped in my tracks by a familiar raucous laugh and discovered my wife and son doubled-up behind a big bookshelf. Obviously, the espresso had kicked in.

My wife, who was almost in tears, held up a book entitled *How to Take Care of Fancy Rats*, while Adam clutched a tome called *The Psychology of Cats – a Self Help Guide*.

They were perilously close to being thrown out, and me with them, so I headed for the toilet before we all ended up out in the lane.

There was a pair of ladders in the loo and signs of ongoing renovation, which explained the Doctor's concern about the toilet being ready.

Once I'd gone two rounds with the ladders and stuck my left foot in the hole in the floor, I settled myself down with Tintin.

Only in a shop full of paper could there be a loo with no toilet paper. When my wife and son spotted me waddling out – fully dressed, of course – I thought they were going to need oxygen.

A bloke in the back shop threw me a roll of paper towel, but by the time I'd got back to the toilet it was occupied, so I had to hover gingerly outside the door, pretending to be interested in a book about beef production in Argentina.

"Honestly, what a laugh that was," said my wife as we walked to the underground.

"I'm dying for a real espresso."

Up the Drain

For some reason, catastrophes always strike last thing at night, just as we're putting out our imaginary Flintstone cat. That hour between 11pm and midnight is a dangerous time in our house – anything can happen and a lot of it has already.

So far, the roof has sprung a leak – twice – the heating has broken down or gone into overdrive turning the house into a sauna, our courtyard has flooded to the height of eighteen inches, a tree has fallen down and almost crashed through a window, the chimney has been blocked and filled the house with smoke, the TV aerial has blown off and crashed into the roof and the microwave has exploded.

You wouldn't think there was anything left to happen, but country life is full of surprises, although since most of them seem to happen around 11.15 at night, they are at least punctual.

The big daddy of them all arrived recently, right on cue. I had been out

reviewing a musical about a man-eating plant and all the way home I had two things on my mind: what material the prop-makers had used to build the huge carnivorous plant, and the loo.

The two things were unrelated, although the plant was like a big toilet that consumed innocent bystanders.

We have a choice of two toilets in the steading, the one in the bathroom is white and the en-suite shower room one is blue, so you can oscillate between the two, satisfying your needs and your colour mood. They are, of course, deviously intertwined, inasmuch as they both speak to each other – if you get my drift – which they often do.

I went for the blue bathroom, even though I had to pass the white bathroom to get there. This is a good example of how your bladder can control your powers of reason.

I have no idea how deep the water is meant to be at the bottom of a toilet bowl, but I know when it's right. My suspicions deepened, as did the water, as I did the needful and, once I was finished, I gave the water level a concerned cursory glance as I dried my hands.

After I had phoned in my review, I decided to check if the water level had dropped. When I discovered it hadn't, I flushed the toilet again, convinced that would do the trick, but it didn't, it made it worse.

My wife was busy, so I made a discreet check on the white toilet, convinced the water level would be normal, but when I lifted the seat I actually jumped back and exclaimed in silence because the water was higher than the other toilet.

I had stumbled on a conspiracy and, by the looks of it, I was just in the nick of time. It was 10.50pm, so I had only a few minutes to avert disaster.

I found an old plastic beaker and began bailing out the white toilet. But since I was emptying the beaker into the sink, I was inadvertently pouring the water back down into the toilet.

I tried the same method with the blue toilet and was baffled.

Meanwhile, the water level was still rising, about half-way up the bowl, and a murky element was beginning to creep in, to say nothing of the smell.

I was on my knees in the shower room with my head in the toilet bowl when my wife appeared.

"Enjoying yourself?" she asked.

I have no idea what she thought I was up to, but she didn't have time to ask, because the toilet water drew back, seemed to hold its breath for a moment and then began to boil and rise like brown volcanic lava.

My wife screamed and we both started running around like proverbial headless chickens until we came to our senses.

The water in the white toilet was also rising, but not as fast as the blue one, so we tackled it first.

No matter how much we bailed it out, the water continued to rise and was now almost up at the lip. We were filling an old jelly pan in seconds and I was throwing it out into the courtyard. We had quite a system going, but we quickly realised we were on a loser.

The panic that gripped both of us was nothing short of sensational. About ninety per cent of our steading has Junkers beech flooring, so you can imagine what ten gallons of fetid toilet water would have done to that.

The smell was now overpowering and making me retch, although it didn't seem to bother my wife, but then she was too busy screaming to notice.

The only thing to do was call an emergency plumber and, of course, the first two had their voice mail on; the third was extremely calm and a complete star.

I can't remember who he was, but I'm convinced he saved our house.

I was in the kitchen when I got through to him and blurted out what was happening.

"What's that noise in the background?" he asked immediately. I thought at first he meant my wife shrieking, but then I noticed the washing machine was on. The plumber ordered me to switch it off and gave me a crash course in waste water. We had a blocked drain by the sound of it, but as long as we didn't use any water or either of the toilets the level would stay where it was.

We manned the pumps for another hour until we were happy that we weren't going to be drowned in our sleep.

The next morning, I checked the septic tank, which is buried under one

end of our rockery, and it looked a little on the busy side, but then it hasn't been emptied in seven years. I called Noswa and they said they would empty it that day.

I then went to work to do the toilet.

Just to make things more interesting, my wife cancelled Noswa and called the Drain Doctor.

Walter turned up at lunchtime, just as I pulled into the drive; he was a handy country bloke who looked a bit like Oliver Reed. I helped him lift the stone manhole cover, but I'm afraid that was really the end of our working relationship.

The drain is about four-feet deep and it was completely flooded and full of huge floating log-like affairs.

"Silt?" asked my wife, in her finest Kelvinside accent.

"Similar word," said Walter, smiling wide-eyed into the drain.

When he was finished, he said he had never seen so much antique crap in his life. Stupidly, I thought he was referring to our old septic tank. But he wasn't. In case I was in any doubt, he produced a selection of it for me to boke past on the way to my car; it looked like a large model of Ayers Rock.

Another call to Noswa and they emptied the tank within a few hours. Almost miraculously, life returned to normal. Until, of course, the next late-night country challenge.

The Branch Manager

APART from the vigorous wind, it was a lovely day for a walk – an almost cloudless blue sky, a searing sun, but just enough of a nip in the air to remind you that you weren't on holiday enjoying gentler climes.

From the house on the hill, I could clearly see my wife about a mile away below me, moving along a narrow road. More of a country lane, really, with hedgerows on either side shielding wide, expansive fields, some dotted with sheep.

Beyond the little road, the landscape rolled out to the horizon with a couple of castle tops acting as landmarks. It was just the sort of scene an artist would happily set up an easel to paint.

By a grim quirk of fate, my wife was carrying one of her paintings; in fact, it was the painting I could see rather than my wife, because it obscured her completely and it looked as if it were moving along the road by itself.

Four larger than life children caught in mid-party had apparently escaped and hit the road in search of adventure. Occasionally, as if by a whirl of magic, they turned for a moment into a woman in black who had thoughtfully brought her own startling-white background with her.

Just ten minutes earlier, if you had been passing the end of the road behind me, you might have seen this wild-eyed but nonetheless elegant woman in black screaming blue murder and beating a silver car with a stick in true Basil Fawlty style.

Meanwhile, a man in a long grey coat cowered at the side of the car with both hands over his head.

Several people must have witnessed this extraordinary scene, including the driver of a Tesco delivery van, which slowed down rather promisingly but then sped off when the woman in black threatened it with her stick.

Still, it was all serene and plain sailing now. My wife was some distance away by this time, so I thought I would phone her and suggest that she have a breather while I catch her up and take my turn with the five-foot painting.

I had been left to tell the people who lived at the top of the hill about our car blocking the end of their road. The woman who answered the door gave me a suspicious look and, quite right, I had appeared on foot from nowhere in a slightly windswept, dishevelled state.

She was full of sympathy until she remembered she was having a carpet delivered and the large van was expected within the hour.

I assured her my car would be gone by then. Unless I was mistaken, I had breathed fire down my mobile phone straight into the ear of the bloke at the garage service desk. It had blown out his other ear and scalded the girl standing next to him. I heard her yelp, so it must have done.

In fairness, I wasn't asking for much. The garage had just fixed my car and it was now severely and dramatically unfixed just two miles from our house.

We were barely alive, so I had demanded a helicopter rescue service.

The bloke stuttered, knowing there was no room for laughter. I told him a recovery vehicle within the hour would do and that he would be hearing from me again, very soon.

I had to hang up at that point because my wife had found the big stick and had started attacking the car with it.

I tried to intervene briefly, calm things down, but in the end I just hid.

To be honest, I couldn't blame her and if I'd found my own stick I would have joined in.

It really was the end of a long and tediously winding road of misadventure and the car just happened to be a very large, handy stationary target.

About a quarter of an hour earlier, we had set off with joy in our hearts and a big painting stuck up the rear end of the car.

We had a new clutch, for which I had paid a handsome price less than twenty-four hours earlier.

At the end of our road, a car pulled out in front of us and almost came to a standstill. It was bunnet man and his wife doing a bit of birdwatching from the comfort of their vintage car.

I think a sedge warbler caught their attention because they almost ground to a halt with excitement.

At the junction with the main road, a pheasant held court for what seemed an eternity.

Normally, my wife doesn't like me overtaking dawdlers. She says it's expansionist and that's how Hitler formed bad habits. But on this occasion, she was telling me to drive over the top.

Personally, I would love to own a vehicle that could do that, but secretly I know I would be pandering to my inner Nazi.

I waited until we were on the straight main road and after travelling at twenty miles an hour for a few minutes, I cracked and overtook.

As we drew level, something rather memorable happened. Bunnet man and his wife stared at us, not in an irate manner, but more in amazement, as if we had turned into a huge silver bird.

I went up into third gear and it wasn't there – in fact, neither were second or fourth. I checked again for third, but it still hadn't turned up.

Realising we were a turkey or, worse still, about to go extinct as a dodo, bunnet man crawled past us while we began grinding to a halt on the wrong side of the road.

In a matter of seconds, my wife had gone from amused disbelief to absolute horror and now extreme hysteria.

I have no doubt we were lucky; if we had been on a busy road or a motorway, it would have been a very different, rather short story.

Trying to maintain some air of control, I pulled the car calmly into the nearest opening, which happened to be the bottom of a hill, and we stopped.

Actually, going for a two-mile walk through lovely countryside on a crisp, clear day was probably very therapeutic.

But then we had to contend with the painting.

Acting like a giant kite, it continually threatened to either pull us over or push us into a ditch.

I took over for the last stretch and as we went through open country, the wind reared up and I had to stop and hang on for my life as I was spun round like a human weather vane. At least my wife laughed.

We would probably still have been laughing with sheer relief if we hadn't realised that I had left my wallet with all my bank cards and driving licence in our unlocked car and then it was all about that stick again.

Wizard Fun

AT THE stone circle at the top of Aikey Brae, some free spirit had obviously thrown caution and their underwear to the four winds. Hanging from a branch of a tree, there appeared to be a pair of white knickers.

These things can happen in these wild, ancient places: one minute you're innocently breathing in the atmosphere and the next you're daubing on woad and dancing with a fire-eater who weaves his own sandals.

There was no call for a closer inspection of the dangling pants, but we had to pass underneath them to go back through the dense pinewood and down to the path, so we couldn't help noticing that they were in fact full of coins and nothing more exciting than an old hankie.

"Oh, that's all right, then," said one of our party, "the old hankie full of money trick tied to a branch beside a stone circle; you see a lot of that sort of thing round here."

For some reason, we were all torn between scarpering and helping ourselves to the loot. Either way, apparently, "an ancient curse would likely befall us", as someone intoned darkly. In the end, none of us liked the sound of that, so we left the money hankie in peace.

Someone had obviously gone to a lot of trouble to tie the hankie's ends

shut and then attach it securely to a branch that was probably just the right height to be stroked gently by the rays of the rising sun, or the settling moon. It was an offering to a higher power than any of us and it was slightly unsettling.

"I knew something like this would happen," whined another member of our party, a reference to the fact that we were on our way to the Wizard Festival at New Deer.

It was probably the last old hankie we would see that day dangling enticingly before us packed with hard currency, but oddly the very idea of it had made an indelible impression.

Like explorers finding their path suddenly peppered with skulls on poles, there was a sensation that we had strayed into a deeper unknown than we had bargained for.

Eventually, after much ducking and diving, we broke free from the dark stockade of pines and in the distance, hovering over the strawberry blonde cornfields, were the magnificent blue tents of the Wizard Festival. We gazed at them suitably impressed.

"Two thousand years ago, they would have been Roman tents," reflected someone behind me.

"Now they knew a thing or two about festivals," added his pal sagely.

East of the three large tents there was a busy campsite. The car park to the south looked just as full.

We listened intently, but there was no hint of the wild electric rockers we had been promised, only a lark twittering above us, the rumble of a distant tractor and a dog barking for his dinner. At New Deer, however, we were comforted when we spotted a band of exotics lounging outside the pub.

"Festivalgoers by the looks of things," announced a voice from the back of the car.

"Could be the local Pict enactment society," chipped in someone else. For some reason, no amount of explaining or dishing out of leaflets and a web address could convince our party that they weren't on their way to a festival of wizards.

"Will there be warlocks?" was a common question, and "Do you get lady wizards?" was asked several times.

"I hope it's not all Harry Potter," was another moan. The trip to the stone circle had, of course, confused matters further.

In a way, I was banking on this happening. I had only two festival passes to go between the five of us and one of them was mine, so there was going to be a threesome enjoying a picnic in the car park.

Fluorescent jackets are the modern totem for action and there were plenty of them on display on the road up to the car park. With the window down, there was a distinct if not unpleasant mash of music in the air, like three rock bands playing at once, all trying to outdo one another, which in fact they were.

"It's not a music festival, is it," chorused the three amigos in the back of the car.

The last time I was at a music festival I was in a band playing on a makeshift stage which after having collapsed at one end was being held up by a dozen burly, half-naked Hell's Angels.

I imagine if the audience hadn't been busy "freaking out" this might have looked like a detail of an allegorical painting by Hieronymus Bosch entitled something like 'Pride Held Aloft by Vanity'.

This magical scene came stumbling back to me like an old dream as we were being searched at the festival gate. I must be search-worthy, because I've been searched professionally all my life; certainly I was searched long before it became fashionable. I do remember lots of people searching for stuff at music festivals in the 70s, mainly their minds, which they had evidently lost.

A few minutes later, armed with a piping-hot latte and a spicy lentil crepe, I was standing in the "axis of evil", the spot where the music from the three bands that were currently performing in separate tents met and fused into a noise that made your inner wolf howl.

Young, intense-looking people jumping up and down on very stout stages were responsible for all this displaced sound. Six feet inside the first tent and I immediately grew nostalgic for the days when I didn't wince at every drumbeat and I liked it when the bass beat stuck its hand inside my stomach and played with my lunch.

Half a mile away, that lunch was being scoffed in my car by people listening serenely to *The Archers*.

"Well," they would ask when we returned, "did you have a Wizard time?"

Fortunately, I wouldn't hear them because my ears would still be ringing from the call of the wild.

The Five Winds

THEY must make a special aroma for school gyms, because every one of them smells exactly the same. You would think this would be impossible, but it's a smell we all recognise and, depending on how much of a psycho your PE teacher was, it's a smell that has the power to conjure up a shiver of dread no matter how old you are.

It's probably this scent of fear, combined with testosterone and wooden floor varnish, that I was turning up my nose at as we waited for the Tai Chi class to begin.

"What's wrong?" said my wife as we watched everyone file in. "Sinuses bothering you again?"

My sinuses get blamed for so many things; I'm not sure what I would do without them.

I happened to mention the smell of the gym and my wife was off.

"Wonderful, isn't it, takes you right back," she enthused, filling her lungs like a Carry On film gym mistress.

I've never seen my wife's collection of athletics medals and trophies. I've been shown a swimming certificate on several occasions, so presumably she had to go through a gym to get to the swimming pool. She does, I have to say, possess the ability to swim relentlessly, but this was Tai Chi, a much drier pursuit and a lot less taxing, I imagined.

My wife had spotted a mutual friend and was now warming up by capering

about with her and having a right old time to herself while I stood around like a shoe-shop manager casting a detached eye over a group of women in their stocking soles chatting about appropriate footwear.

Needless to say, the Tai Chi class was my wife's idea and I was all for it until I discovered it was a martial art. I mean, someone might get hurt, you never know, and that someone was more than likely going to be me, particularly if I was paired up with my wife.

I was a big fan of the TV series *Kung Fu* when I was a kid, but my interest in defending myself ended with David Carradine walking off into the sunset in the final episode.

My father boxed when he was in the Navy and I have to say it's one of the reasons I have a broken nose.

I felt slightly cheated when I found out Tai Chi wasn't a semi-mystical, slow-motion form of exercise. I had always imagined it was a mesmerising eastern type of callisthenics that was practised on Californian beaches by groups of people in loose-fitting pastel-coloured clothing.

I also wasn't convinced I was likely to find myself in a position in which a martial art would come in useful. You don't tend to fend off many assailants at chamber music recitals or art exhibitions.

"But look," said my wife, pointing at the Tai Chi web page, "the type we're enrolling in is called Five Winds: that's you down to a tee."

Which was another point worth considering. I accompanied my wife on several occasions to a Hatha yoga class during which people broke wind at irregular intervals with amazing power, myself included. There is a particular yoga position that is guaranteed to bring out the worst in you and since the yoga is practised in serried ranks you do tend to get a faceful every so often. In these circumstances, I reckoned it was quite permissible to give as good as you got.

Apparently, the relief was quite visible when I didn't go back. I was the only bloke and the women just couldn't compete.

"Nobody minds that sort of thing," said my wife.

Just to be on the safe side, I kept an eye on what I was eating that day and was still going to the loo while the class was filling up.

Uppermost in my mind, apart from the smell of the gym, was whether or

not I had remembered to wear a pair of socially-acceptable socks. Shoes were being slipped off everywhere I looked, so I was now wondering if I should keep mine on or not. I decided to slip one off slightly for a sneaky look at my socks and suddenly there was a woman peering over my right arm.

"That's right, just take your shoes off – bare feet or socks," she said, so that was it. Fortunately, I was in luck, my socks were both black, not the same black, but close enough for a Tai Chi class in a whiffy gym.

My wife missed this bit because she was still capering about, so she kept her clumpy trainers on throughout the whole class. This gave me an immediate advantage, not that we were in a competition of any kind; four times on the way there I had been reminded of this fact. It didn't sink in, though.

The other one was: "Remember, it's not an audition for a Kung Fu film."

Just as well, I thought, fairy-weight woman in her trainers wouldn't have stood a chance.

As it turned out, you might have thought it was an audition if you had peered in the door. The half dozen or so beginners of all shapes and ages were lined up at one end of the gym while everyone else filled the rest of the space going through a series of highly-complex movements in astonishing harmony.

This army looked as if it was advancing towards us very, very slowly while we waited in anticipation for the moment, possibly two hours down the line, when we would have to defend ourselves very, very slowly. For some reason, I felt relaxed just watching them. In fact, that would have done for me as a starter class.

But then Brian the Tai Chi teacher started taking us through what's called the square form. Baffled, we did our best, but ended up in physical knots. Half an hour later, we were still baffled, but we were starting to make something of it.

For some reason, my wife kept moving me towards the wall while we turned and turned in defence against our invisible assailant. To some degree, that's what's happening when you see someone practising Tai Chi – they're defending themselves in an extremely relaxed manner against an invisible attacker.

My wife's attacker was a giant show dancer by the looks of things. At certain points, she looked like she might have been in the musical Chicago, but most of the time she was in full Isadora Duncan mode – big, broad, theatrical-dame gestures, her feet sliding apart thanks to those chunky trainers.

Funnily enough, we're both hooked and have started practising our mystical moves of an evening as we tread the policies. You have to move as if you're sitting on an invisible bench, so we must look like a pair of very canny, slightly-constipated hand-shadow experts.

At least, outside, the five winds aren't all mine.

Lady on the Phone

WHILE most people are getting spruced up for a special night out at the theatre, there is a brand of folk who are busy stuffing rucksacks and dragging on old damp anoraks. I've never seen the point personally. Admittedly, some theatres can be draughty affairs, but they would hardly qualify as the great outdoors.

There were two of these nocturnal backpackers directly in front of me at the bottom of a theatre foyer queue that stretched up a flight of stairs to an invisible ticket desk. Every so often, the bloke, who was called "Keef", took a step back to rebalance himself and I took the full brunt of his rucksack directly in the chest.

His partner, "Debz", swung around a lot, looking at people, so my left arm was being constantly scuffed by her enormous backpack.

Whatever was in their backpacks it was decidedly unforgiving. Eventually, after the umpteenth close encounter, I finally cracked.

"Emergency supplies is it, in the big rucksacks?" I asked, "a kit house that you're planning on building during the interval, something absolutely vital that you just had to bring along to an evening's light entertainment?"

They both stared at me in silence with nervous bewilderment.

"Come on, give me a clue; what letter does it start with?" I continued, but they weren't having any of it.

Keef sniffed and gave me a withering look.

That's when an over-dramatic woman turned up and stole the show. Not at first, because we were all too polite to pretend to notice her, but she grew so large that eventually there was just no getting away from her.

I was standing about four yards from the vestibule doors, which were closed. The exterior door, however, was open, so I heard her coming. For a few minutes, she was just a posh voice drooling and barking into a mobile phone – dahling this and sweetie that.

There was someone called Jeremy on the other end who was obviously trying to avoid her, because she kept ordering the person she was speaking to to put him on, but apparently Jeremy was nowhere to be seen.

"Listen, sweetie, don't mess me around," she was saying loudly. "I know he's there, he's hiding, go upstairs and get him. Wait, take the phone with you. Oh, for goodness sake, give me strength."

The queue had now built up behind me and a number of people were already looking at one another, obviously hoping that the posh loud woman wasn't coming our way.

Personally, I could hardly wait; I was fed up queuing and the rucksack couple were no fun.

She came in backwards through the inner vestibule doors – big hair and an even bigger coat. She was right at the other end of the glamour scale from the backpackers and Debz took an instant dislike to her while Keef turned bright pink and couldn't keep his eyes off her.

She was also smoking, so it was only a matter of time before she was lynched. But before the crowd could whip up some fervour, she was gone in a plume of smoke and a frothy wave of "simply divines", a diva hand on the brow.

The queue smiled and tittered. Debz readjusted her rucksack and shot Keef a glower.

If they were casting an Agatha Christie murder mystery, she would have been the star victim, a woman who stepped out of the cold wet night in the 1930s and who met an unfortunate end in a theatre. It was the most fun I'd had in that queue and just when we were beginning to miss her she bounced back, still on her mobile and still looking for that pesky Jeremy.

"No, listen, dahling, you must give him my number and get him to ring me immediately. It's absolutely vital; do you understand?" she was saying. "Well get a pen and write it down."

Then she was asking people for a pen, but nobody had one except me, but it was stuck a long way down in my inside jacket pocket, caught in the lining most likely, and wouldn't budge.

"Come on, one of you must have a pen; for goodness sake, help me," she was shouting and snapping her fingers.

Keef suddenly had a pen in his hand and held it out, looking as if he had been hypnotised. The woman took it with a flirty smile that was meant just for Keef, but Debz saw it and wasn't happy and then the woman realised she wasn't the one that needed a pen, it was the person she was talking to that needed one to write down her mobile number.

"I'm going mad," she announced into the phone, "absolutely mad. He's driving me mad, of course, and he's doing it intentionally. Well, it's not going to work, you can tell him that; not working, I'm fine, I'm perfectly sane and I'm not going away."

It was here that the queue seemed to have a communal revelation and decided that posh shouty woman was actually an actress performing the pre-show entertainment. Once we had reached that conclusion, most of us decided she wasn't that good and lost interest, although Keef and a couple of other blokes were completely hooked, to the point that our actress began to look concerned.

"Listen, there's a load of dodgy blokes leering at me; can you put Jeremy on right now," she said in a low voice into her mobile. Some of the dodgy blokes thought this was very clever and chuckled away.

"What's it about?" someone asked.

[71]

"Don't know," came the reply, "it's a mad woman on the phone."

Then the queue began to move rapidly and everyone applauded while shouty lady flounced around.

"You were very good," said an elderly lady, taking her by the arm as she passed. "For a moment, we thought you were a real person."

The woman shook her head and left declaring into her mobile how she had just encountered some imbeciles and that Jeremy's end was definitely nigh.

I had her miscast. She wasn't a femme fatale victim at all; she was the chief suspect.

Lofty

I CAN'T remember how my wife landed the plum job of going up into her father's loft, but somehow I was left sulking at the foot of the Ramsay ladder.

Lofts and their subsequent exploration have always been one of my duties. Initially this was by default, because I was the only person in the house who knew where I had hidden the torch and, knowing that my wife loves a good rummage, I've frightened her off with menacing scenes of cobwebbed horror.

I floored the loft in our new cottage to give us extra storage space and, of course, so I could roam around in it without unwanted diversions such as sticking my foot through our bedroom ceiling.

So far, all my wife has managed to get is one foot on the ladder before I warned her off.

"Careful," I shouted, as I leafed casually through a box of old books, "it's very tricky up here."

All this made her squirrel-like ascent into her father's loft all the more surprising. Ostensibly, she was up there to look for a mattress that we were borrowing for a few days.

Forcing your grown-up children to bunk down on the floor when they decide to stay over for Christmas is one of the pleasures of living in a small empty nest.

Even better still is the thrill of seeing them bunk down on a mattress that's been hibernating in their grandparents' loft long enough to become a family heirloom.

"You'll have to look after it," shouted Ian, my father-in-law, up into the twilight world of his loft. But there was no reply. For all we knew, my wife had vanished through a wardrobe into the magical but faintly threatening world of Narnia.

"Don't worry," I said, comforting Ian, "we'll feed and water the mattress every day."

I think that's what he was afraid of.

After some time hanging around in Ian's narrow hallway, with very little in the way of spectacle to occupy us, we found our conversation had moved easily from one topic to another, until we began to wonder why we were standing holding a ladder that wasn't going anywhere.

Eventually, we even lost interest in what we were talking about, but then Ian remembered his daughter was up in his loft and he bridled as if someone had stirred him from a cosy nap.

"Have you found it yet?" he shouted.

Frankly, I was interested to hear the reply because I couldn't remember why my wife had gone up into her father's loft in the first place, apart, of course, for a good old rake.

By the sound of all the interesting stuff being dragged and bumped around she was having a fantastic time.

"I think I'd better see if she's all right," I said, starting to climb the ladder. But Ian gripped my arm and frowned at me as if I had turned into the murderous Richard Hillman from *Coronation Street*.

"Not so fast," he said. "I'm not having both of you doing a disappearing act."

"I'll just be a minute," shouted my wife suddenly. "I think I've spotted it."

"Spotted what?" I asked Ian, who just shrugged and shook his head.

"Look out, here it comes," shouted my wife from directly above us. "Watch your heads."

The last time my wife said that, I ended up concussed, so I stepped back into the bathroom and waited until the coast was clear. Ian, meanwhile, rather bravely, I thought, stayed put and watched with interest as the loft hatch was filled completely with a giant roll of blue foam wrapped in dusty polythene.

"What on earth's that?" I asked meekly.

"A big roll of blue foam," replied Ian flatly, "wrapped in dusty polythene."

"Not a mattress?" I asked.

"Not the right mattress," declared Ian.

Whether it was the right mattress or not, it didn't take us long to work out it was jammed in the hatch like the pupa of a massive moth. Either that or the loft was giving birth.

I shared these thoughts with Ian, but he didn't say much. I felt a Broons moment coming on.

I was first up for a tug, but the thing refused to budge.

Even although the foam was sticking out by at least a couple of feet, I couldn't pull it any further because it was almost impossible to get a grip on the polythene.

Ian decided he didn't have time for what he called "malarkey" and stepped up for a three-second grapple.

"Look what your wife's done now," he puffed, red-faced and sweating.

Interesting, I thought, how his daughter gets transformed into "my wife" the moment something massive gets stuck in the loft hatch.

I gave it another go, telling my wife to shove down on the foam as hard as she could, but it wasn't moving. I could just about hear her talking away and laughing hysterically above us like some madwoman locked in the attic. Telling her she had turned into Mr Rochester's crazy wife in *Jane Eyre* didn't help.

Ian, meanwhile, had lit up a pipe and was frowning up at the big blue growth on his ceiling like a scientist bemused by an experiment that had gone horribly wrong.

"Hurry up," shouted my wife suddenly, "I'm getting hungry."

That settled it, the polythene had to go. I stepped up the ladder and grabbed at it with both hands, sinking my nails in and tearing it open. Once I had a good grip, I jumped off the ladder and pulled the foam down with me.

It seemed to go on forever and about halfway down it showered on me what some people might have thought was burnt rice. Unfortunately, I know mouse droppings when they hit me on the head.

The floor by this time was covered in droppings, mixed with the crumbs of blue foam that were too big for the mice to take home with them.

Ian regarded the scene with interest from behind the sanctuary of his pipe and told me that under no circumstances would he ever let mice in his house.

"So who do you think ate the foam?" shouted my wife from the hatch. "It certainly wasn't me."

I took all this in my stride, knowing that now I would be able to take my rightful place in the loft.

First the giant foam pupa had to be transported to the garage, during which adventure I asked Ian to reflect on the possibility that someone had been boiling rice in his loft, burnt it and in an attempt to conceal the evidence had poured the lot inside a big roll of blue foam. This seemed to be a more comfortable alternative to having mice in his loft.

"There's nothing up there worth keeping, anyway," he mused grimly.

I'll be the judge of that, I thought.

It took me five seconds to find the mattress we were borrowing and I spent the next quarter of an hour sitting dewy-eyed over a stack of my old paintings and drawings.

"Find anything interesting?" asked Ian later.

"Not really," I said, "but you've got some very artistic mice."

Animal Park

VERY little prepares you for the hair-raising experience of coming face to beak with an emu of an afternoon. They are the descendants of the seven-foot terror birds that I assume must have terrorised smaller birds and mammals when the dinosaurs faded out.

I have seen an illustration of a terror bird and admittedly it appears to have the power and resilience of a tank and a beak that could be the end of a large sheep, but the principle is the same.

The long neck of an emu, suspiciously like an arm – in Rod Hull's case, an actual arm – also closely resembles a big snake. The topping of the goofy head and the beak turns it into a nightmare snake on skinny legs – make that a nightmare snake that has swallowed a sheep whole and is experiencing some trouble digesting it.

That big old lump of a body looks large enough to throw a saddle on to and I'll bet there is somewhere in Australia where someone has actually done that. There are probably organised races. An emu can sprint at over thirty mph, something worth bearing in mind when you're a couple of nervous feet from one and it's giving you the eye. Definitely worth a fiver each way.

They have, of course, a certain elegance, a wary, slightly snobby air that lures you into thinking they'll pass by you with their beak in the air because you're too low down the food chain to bother about.

And then there is Michael Parkinson, assaulted on his own chat show by a psychotic emu owned by that man Rod Hull. That image of Parky fighting off the mad bird left a lasting impression and probably did untold harm

to the emu's reputation, branding it as a long-necked, winged harbinger of chaos.

So much so that when we spotted an emu in the distance at the safari park, my son Adam and I stopped in our tracks. My wife, meanwhile, thought we were overreacting.

"Honestly," she chided, "it's not a Sumatran tiger."

We had just seen one of those running vertically up a thirty-foot telegraph pole to snatch a family-size lump of raw meat. It slid halfway down again and then dropped to a standstill, snarling and staring round in case anyone got any stupid ideas. Women clutched their toddlers, revisiting a primitive response that seemed to take them by surprise.

As the tiger got stuck into its lunch, you could hear bones cracking and breaking under its enormous teeth. I heard someone say that a lemur had wandered into the tiger's feeding enclosure the previous week and walked straight into the snack department.

Some lemurs met us at the safari park gate, an interesting experience for people who don't own pets or share their living space with anything with four legs larger than the odd field mouse.

"Do you think they know they're out?" asked my wife, smiling nervously.

"Who, the lemurs?" I asked, and was rewarded with a thump.

Anyway, they looked playful enough, if not downright talented. The young couple in front were photographing them and the lemurs were striking well-rehearsed poses.

At the outdoor café, they were lounging on the table tops like louche old-fashioned rakes waiting for someone to attend to their every whim.

Mostly they got short shrift, particularly from the shop where apparently they go on robbing sprees. Presumably they steal stuffed versions of themselves that they can deploy as dummies when they're digging the tunnel under the wire and the keepers come round for a head check.

"Kangaroos are cancelled," I announced and started heading back down the path.

"Don't be so daft," laughed my wife as she strode up to the gate for a quick chat with emu number one.

They're harmless, she said after a brief discussion. Adam and I walked warily and very slowly back towards the gate as my wife opened it.

"Hello there, hen," she said to the first curious emu, "come away in; you'll have had your tea?"

Obviously they hadn't, because one of them immediately started eating my wife's hairband.

"Quick, distract it, give it some food," she growled as she tried to get her head out of the way of that big beak.

I couldn't remember if emus were named on the food bag, so I took my specs out to check and the moment the bag was visible this horrible beak on the end of a hairy head appeared from nowhere and took a stab at my hand. Everything went dark red after that as I leapt into fight or flight mode and ran for it, I'm afraid to say, followed closely by Adam. We were at the bottom of the path, panting and congratulating ourselves for making such a slick escape, before I realised my wife was still up at the gate cornered by two pecking emus.

"This kind of thing never happens to Ben Fogle on *Animal Park*," observed Adam.

Personally, I think it does, its just that all the bits when he scarpers are edited out.

"Anyway," added Adam as he watched his mother's plight with interest, "I like my birds in the sky or in trees, not six-foot high in my face."

He had a point. Eventually, after doing what looked like a very weird and slightly hysterical dance routine with the giant birds, my wife surrendered her bag of food and her hairband and legged it, quite elegantly, I should add, in true emu style. In our spineless defence I have to say she was warned.

Life at the Hall

THERE was no sign of the Cavendishes at the hall, although Holker is a grand-scale, neo-Elizabethan mansion and we didn't explore every room. But I think you can tell if someone is out; the atmosphere is lighter and the mice are usually quietly at play.

Holker is a Norse word meaning "a rising in marshy land", which as a possible building plot seems a little optimistic to me.

While we took refuge in the tearoom, the marshy bit was busy living up to its name and had joined forces with the sort of downpour we would call biblical but which the residents of nearby Morecambe Bay would no doubt classify as a mild drizzle.

Certainly, it was difficult to see through it and, in my book, rain is quite serious when it's opaque.

It may have explained why I had the feeling the Cavendishes had retired for the end of the season to their charming estate in Tuscany. There are large, mouthwatering scenes of the vineyard in the food hall where you can buy its tastefully-packaged produce.

During bleak days like this, visitors by the coachload gaze longingly at the Tuscan landscapes glowing with life and buy its essence in bottles and jars.

In the tearoom, there was a flurry of some very refined senior citizens at work. The women were apparently strangers to the mysteries of debit-card machines and told every customer as much.

"Not my department, you see," explained our assistant. "I can't even set the video."

"Life's too short," agreed my wife.

The men, meanwhile, retained a lofty distance. Sporting blazers and bowties I had them down as retired cricket umpires, judging by the look of their studious, searing stares. I overheard a couple of them discussing the "gravity of the precipitation", or maybe it was the precipitation of the gravy.

One nodded sagely and the other gazed round empty eyed at the grazing damp tourists. For a moment, I thought he was going to tell one slouching old lady to sit up straight and stop playing with her food.

My wife, however, reckoned they were all retired retainers, butlers, nannies and valets, and she may have been right. The chap who brought the order to our table served us without saying a word or even a glance in our direction, the perfect invisible servant. When I asked for salt, it appeared as if from thin air in seconds and was placed in the centre of the table like a winning chess piece.

The action in this tearoom was equivalent to a provincial station waiting-room at midnight and the strain was starting to show on the staff. One of the gents had developed a sudden stoop and his bowtie had taken up a crazy angle. Someone behind the counter had dropped a side plate and the resulting sudden state of alarm almost warranted a call to emergency services.

Another elderly gent with a distinctly military bearing and a large, well-groomed moustache appeared in the centre of the room and almost at once everyone paused in mid-bite and stared at him expectantly.

"Oh, look out, we're going to get a song," someone quipped behind us.

For a moment, it looked as if the chap was going to make an official announcement, possibly an apology for the worrying state of shock in which most of the customers now found themselves.

He opened his mouth and it stayed open until his upper false teeth dropped down, then he turned and walked back into the kitchen. Everyone started chatting again immediately, then the gent appeared again and paused for a few seconds before retreating in silence. It was like musical chairs without the music.

Into this melee of delight and decorum wandered our mystery guest.

We didn't pay much attention to him at first since the floor show was taking all our attention and because we were enjoying our splendid late lunch.

I had an idea that this old chap had already passed our table on several occasions, but he looked very similar to several other old chaps, so it was hard to tell.

"Is that the same old chap who passed twice a moment ago?" I asked my wife.

"What old chap?" she said.

This gives you some idea of how fascinating it all was. Obviously not as fascinating as a chicken and salad sandwich on homemade bread.

"Have you tasted this bread?" mumbled my wife in a state of some ecstasy.

Then the old chap appeared again, threading his way slowly through the tables with his stick. It took him about five minutes to traverse the room, muttering lightly away to himself, pausing occasionally to inspect invisible things.

He had obviously been out in the rain, judging by the state of his hat and coat, and, just as I was about to ask if he needed help, a group of elderly women made contact and asked if he was looking for someone, but he seemed to just nod and smile and then went on his way again, back and forth across the room before leaving through a side door.

Ten minutes later, he passed by our window like a ghost. Deciding he was obviously lost and in need of rescuing, my wife now leapt into action and went to his aid.

Peering out of the window, I saw her trying to take him by the arm while he did his best to fend her off.

By the time I got outside, they were heading off at a snail's pace through marshy ground towards the flooded car park, so I sheltered under the awning of the ticket kiosk. There was a moment when my wife got bogged down and I thought the old chap might actually give her the slip.

"That old chap's just out for a walk," sniffed the bloke behind the counter. "I think he was bored, bit deaf."

"Well he's going to be rescued whether he likes it or not," I observed.

"Chance would be a fine thing," mused the ticket bloke, and he returned to his newspaper with a wistful sniff.

The Pass

SOMETIMES as you drive across the higher roads of the Lake District, it feels as if the world has come to an end. You can see the narrow ribbon of a road snaking ahead of you up the side of the next hill and there's not a car or a hillwalker in sight.

There's nothing, in fact, to suggest that you are not alone on the planet, apart, of course, from your fellow-car passengers, who are all enjoying the dumbfounding point of view of an eagle while you squeeze the car through a road that seems to shrink at every turn.

"That looks like an interesting little road," my wife had declared. "Let's see what's up there."

The sign had pointed to Troutbeck and Kirkstone Pass and, rather optimistically, I thought we could nip up the road for a few miles and take in the view then head back down for lunch.

Within seconds, this innocuous but strangely tempting road out of the village had become so steep all the blood had drained from my face and collected at the back of my neck, although it's possible most of it was sweat.

Worse still, there was no turning back. It was just one continuous mountain pass road with no turn-offs and barely enough space for two cars to scrape past one another.

Once, in Andalusia, I took my wife's advice and drove halfway up what

turned out to be a cliff face until we reached the point where the car was about to perform a backward somersault.

I had a vision of the car falling back on to its roof and sliding down the mountainside and straight into the dusky blue depths of the lake at the bottom.

It's a moment that still haunts me to this day.

Instead, I managed to reverse back down, trembling all the way.

"Right, panic over," said my wife. "Let's see where that road goes," she added, pointing to a dirt track guarded by a dozy old bull.

Apparently, the EU funding had run out before the road was completed; it was meant to snake up the mountainside at a safe and leisurely angle. Instead, it just stopped dead, but we kept on going.

A similar thing happens in the Lake District. One minute you're driving along between sleeping giants enjoying the sensation of being minuscule and meaningless when your destination turns out to be a deserted cul-de-sac or at best a car park.

As we drove over Kirkstone Pass high above Windermere to the west and Ullswater to the north, I was desperately hoping for one of those dead ends, but the road just continued twisting upward. What had seemed like a good idea a few minutes earlier had turned into a finger hovering over the panic button situation.

At one point, I considered reversing all the way back down to the village, but suddenly we were hemmed in by high, dark slate dykes so we were literally blinkered from the stomach-churning drop. Then thick cloud settled quickly around the roof of the car and we may as well have been blindfolded.

"Aw, what's happened to our view," moaned everyone in the rear stalls.

"See if you can get us out of this fog," added someone.

"What did you have in mind?" I asked. "An airlift?"

"No need to worry, it's just a bank of low-lying cloud and it will soon pass with that brisk easterly blowing behind it," announced my wife the meteorologist.

I wasn't so sure, not having my wind-measuring equipment with me.

For a moment, the cloud cleared just enough for me to catch a glimpse

of a small layby up ahead, so I pulled into it, but kept my lights on. In the circumstances, it was the sensible thing to do. Buses regularly travelled this road and if one came upon us in such poor visibility we wouldn't have stood much of a chance.

So we sat and waited.

"Anyone got a pack of cards?" asked a voice from the rear.

"Apparently, this is the road that William Wordsworth took with his brother John when he walked to Scarborough to propose to Mary Hutchinson," said my wife, reading from a book.

"Scarborough," exclaimed a voice from the back, "I'm not going to Scarborough."

"It also says the view of Windermere from this viewpoint is absolutely unparalleled and not to be missed," she added.

"From which side of the car?" I asked.

"My side," replied my wife, so we all turned and peered out into the impenetrable cloud.

"Bet it's absolutely fantastic," said a wistful voice from the back.

"Marvellous," enthused another.

"Do you think I should photograph it so you can all relish it later when we get rescued?" I asked, but there were no takers.

Instead, my wife suggested that it was extremely rash of me to follow her instructions and take us up a road of no return with no view.

We were saved from any further lively discussion on the subject by the cloud lifting enough for us to see the dyke.

I got out in an attempt to get our bearings and on climbing the dyke came upon probably one of the wildest scenes I've witnessed.

There were four small, hardy ponies grazing on the coarse fell right in front of me. Two of them were drinking from a tumbling stream while, behind them, gleaming Windermere and the whole of the south-western Lake District arranged itself in the soft light like a fading dream.

The ponies gazed back at me unperturbed until suddenly from around the bend up ahead bowled a train of vintage cars decked out in ribbons. It was a wedding party on its way down to Grasmere, where Wordsworth had lived with Dorothy, his sister and spiritual wife.

There was something rather symmetrical going on here; the sort of thing that happens only when you take a road on the spur of the moment against your better judgment.

We were late for lunch, though.

"Well, you can't have your Kendal Mint Cake and eat it," reflected my wife.

The Big Sucker

FOR years, the nine-foot drainpipe at the front of our cottage has been sneakily filling up with rain. None of the previous owners or tenants noticed it, but typically I just couldn't resist stumbling upon it by accident.

Although, to be fair, drainpipe-inspecting is not the sort of thing you would set your alarm clock for. My wife, however, was delighted at my apparent diligence.

"Oh, well spotted," she exclaimed, as if I'd caught sight of a missile hurtling towards the house and somehow managed to deflect it.

"How did you find out?" she continued.

I told her it just came up during a routine drainpipe and gutter inspection and for a moment I thought she was going to faint.

Actually, I had been up a ladder fiddling with the TV aerial cable and on the way down I happened to notice the drainpipe was full to the brim with horrible dirty water. Obviously, it was blocked somewhere, so I got the longest bamboo cane I could find and gave the pipe a sound prodding.

Judging by the length of cane I was using, the pipe was blocked near the bottom and probably had been for quite some time.

"So is it the only one?" asked my wife, catching me off guard. I hesitated for a moment and then assured her it was.

"So you've only got one to empty?" she continued. "Still, that'll be tricky."

I just smiled enigmatically and said it would be a dawdle, because, up until then, it had been. All I intended doing was pouring some powerful drain-clearing fluid down the pipe and standing well back while it worked its rough magic. It never occurred to me I would have to clear the pipe of water first.

Before I did any more damage, I got the ladders out and checked all the other drainpipes around the cottage. Luckily for me they were all clear.

Over the next few days, I kept a beady eye on the drainpipe, hoping the water would go down, leak out, or evaporate, because I didn't have a clue how to get rid of it.

Apart from the sheer annoyance factor, it smelled rotten. It hasn't rained much this year, so that water could have been cooking up legions of bacteria long enough for it to become a weapon of mass destruction.

At one point, I wondered if I could drill a hole through the bottom of the pipe, let the water run out and then plug the hole back up again. I even considered scooping the water out, maybe with a cup attached to some wire. But I couldn't find a small enough cup.

A long sponge was my next brainwave, but if there are nine-foot sponges for sale I've never seen them.

"So when is this dawdle of a plan going into action?" asked my wife, sounding worryingly suspicious.

I tried the enigmatic smile again, but it didn't work. In fact, my wife raised an eyebrow, and that's a bad sign.

Scratching about desperately for an idea, I heard myself announce that I was going to suck the drainpipe dry, using a length of plastic tubing, of course, the sort you can buy in a homebrew shop.

My wife's face lit up; apparently, it was a brilliant idea and I was a genius. One second I was being applauded and taking a bow and the next I was a numbskull again.

"Look," I began, "remember when we used to siphon petrol from cars, well it's the same thing. You just stick the tube in, give it a suck and let gravity do the rest."

My wife couldn't recall siphoning petrol from cars and neither could I, so maybe that's what they call false-memory syndrome, but the principle was sound.

When she told her father about my brilliant plan, my wife forgot to mention the tubing, so I was instantly declared insane. For the rest of the week, my father-in-law nursed a terrifying image of me perched on my roof, sucking away at the drainpipe as if it were some huge straw.

At one point, I thought he was going to be proved right. For a start, I couldn't find a homebrew shop or a long enough length of tube.

But then I stumbled on an old garden hose and got my scissors out.

I wasn't exactly sure what I was doing and I had no idea if the hose had to be a specific length, so I just made a wild guess and cut off a really long bit, it was as technical as that.

Once up the ladder, I started feeding one end of the hose down the drainpipe and, needless to say, it wouldn't go down because it was curvy and it persisted on getting stuck. I had to keep pulling it out and trying to straighten it, but the smell was so bad I thought at one point I was going to reel backwards off the ladder.

Eventually, I persuaded the hose all the way to the bottom, or at least to the blockage, then got down off the ladder and started working myself up to the big suck.

I thought it would be easier if the hose was relatively straight; my sucking power would go further, I reckoned, if it didn't have to go round corners and along bends. So I stepped backwards on to the quiet country road that runs along the front of our cottage, gave the end of the hose a good wipe and started sucking.

The trick, of course, was to stop sucking the moment that filthy, fetid water shot into my mouth, but I was ready for it.

Unfortunately, nothing happened, so I gave it another almighty suck and the country bus appeared from around the corner and slowed down long enough for the passengers to wonder why I appeared to be inflating my house with a garden hose.

Later, one of the passengers told me it looked more like I was playing the house, as if it were some huge wind instrument.

Next, a car came down the road and stopped at the junction just a few feet from me. I could see the couple looking back at me, their faces etched with bewilderment.

And then I had a mouth full of disgusting, gritty, slimy liquid.

Bits of horrible stuff rolled under my tongue and swam around the back of my molars. It was horrible but, quite honestly, I felt as if I'd struck oil.

Once I had dropped the hose, the water poured out a treat and I bolted inside for ten rounds with the mouthwash.

"Och, that's an old trick," said my father-in-law. Obviously, the sight of someone siphoning drainpipes was at one time quite commonplace.

Whether or not the drain-clearing fluid did the job is another matter that I have no desire to research.

The Accidental Passenger

THERE is something to be said for being chauffeured around. It leaves you free to comment on the general state of anything that doesn't take your fancy, such as the knee-high weeds along the roadsides or the mysterious behaviour of drivers less skilled than yourself. If you're not careful, you can even get road rage by proxy, which is guaranteed to enliven even the dullest of journeys and, of course, you can annoy people you haven't spoken to in ages because you can make phone calls while you're on the move. In fact, when my fractured ankle heals and my plaster comes off, I might hire a full-time driver.

Somehow, I can't see my wife applying for the position, even if she could. The only reason she hasn't strangled me so far is because she would have to take her hands off the steering wheel.

Apparently, I'm not a good passenger, and the fact that I'm only a novice is no excuse. I'm not good at being disabled, either, even if it is temporary. Just three weeks in plaster and I've turned into the disabled-access pest.

One of the problems with being on crutches is that you are not in a wheelchair. Even the shortest staircase might as well be the foothills of the Himalayas, but a wheelchair ramp is almost as bad.

Crutches don't like inclines of any kind and neither does my plastered ankle; it can't bend in the relevant places, so it has nowhere to put itself.

Gravity, meanwhile, conspires to pull me forward or backward depending on the direction of the incline. Sometimes, if the wind is strong enough, I can wobble back and forth for ages.

Wheelchair ramps are also, by their nature, often twice as long as you expect, and if they go down a steep hill they double back on themselves all the way to the bottom.

I got stuck in one outside a university building and the place was almost closed for the weekend by the time I got to the door.

I also had a big red face and a sweat on me like a pack mule, so I was in no mood for the usual formal, but cheery, escort to the lift.

That's one positive thing about not being able-bodied: you meet lots of people. Principally because no one trusts you to operate a lift on your own. There's always a key or some exclusive pass that only staff are allowed to use, so you get special treatment whether you like it or not.

Having said that, I've learned already that being obstinately independent can backfire on you. In that same university building with the wheelchair chicane, I was escorted back to the special secret lift by a nice librarian who asked if I would manage to get out at the ground floor.

"No problem," I declared and waved her off as the doors slid shut. Unfortunately, someone had decided there was no need for a ground-floor button, so I confidently pressed the first floor button. Two minutes later, I was standing in what appeared to be a basement boiler-room listening to the lift doors close behind me with a little snigger.

Now I've really done it, I thought. Not only am I defenceless on crutches, I've also broken the cardinal rule of all horror films and taken a solo trip to the basement.

After waiting five long, nervous minutes for the lift to come back down again – during which I started whistling for comfort – I got back in and pressed the second-floor button.

When the doors opened, I was presented by yet another basement.

Why any building would need more than two basements is beyond me.

Quite honestly I could have ridden up and down in that lift all day, but I spoiled it by pressing the third-floor button. Naturally, it turned out to be the ground floor, where my wife was waiting to give me a row for playing with the lift.

An hour later, stuck in the car in a shopping centre multi-storey, I delayed the inevitable expedition to the toilet until my bladder decided it had reached its critical mass.

The disabled toilet wasn't far, but it must be a hot target for burglars because it was locked up like a high-security Swiss bank vault. A sign told me to go to the management office where I would be given a key, which of course I would have to return – no mean feat on crutches and with a bladder the size of an airship.

However, it wasn't all bad. The girl in the office told me I could buy my own personal key for a pound if I was planning on using the disabled toilet on a regular basis. I thought about it but, in the end, I had to admit the toilet was a little too far from the rest of my house and the girl understood.

A few days later, my wife decided I could go out again and annoy people, so I was taken to Aberdeen College, where I was due to judge part of the art and design end-of-year show.

I liked the sound of this: not only could I make a complete nuisance of myself, I could pass critical judgment on the works of others and everyone would be grateful for it.

The place was packed and since I looked so daunted, a wheelchair was produced. Fantastic, I thought, now I can give everyone that steely Bond-villain gaze I've been practising since I was a kid.

But there was a slight problem, mainly the fact that I was at least three feet under everyone's eye line. So, within a few minutes, I ceased to exist.

At one point, someone announced that they would wait until I came back

before proceeding to the next section and I was sitting right under their nose.

I think everyone should be pushed around in a wheelchair, at least for an hour. It gives you an unforgettable view of the world, mainly of people's crotches.

Every so often, when someone asked me a question, I forgot where I was and replied to their groin.

I was also abandoned on several occasions and left staring helplessly up at people as they passed blithely on their sure-footed way. Left in a corner with some intriguing textiles for company, everything went dark suddenly.

When I looked up, I discovered a woman with a huge chest had roofed me in. She had leaned down to examine a piece of fabric that had taken her fancy and almost smothered me.

When my wife spotted me, she whisked me out into the light and scolded me for taking advantage of my position.

Sadly, we had to give the wheelchair back when we left and I was back sulking at normal crutch height again.

The Lock Out

I HAD a powerful premonition of disaster the moment I unscrewed the handles from our porch door. Either that or it was just common sense, which makes a pleasant change.

So when I took out the bolt, I laid it carefully on the inside window ledge and made a vivid mental note. It would be just typical of us to get ourselves locked inside the house, I thought, and told my wife as much.

She laughed and agreed that would be terrible. But since I was painting

the door, there was little chance of it being closed, particularly with us on the outside. Which would have been just as bad.

For a moment, I tussled with that scenario, pictured myself struggling to climb in through a window or trying to open the door with a makeshift handle and decided to just leave the bolt where it was.

It was still a mini-crisis waiting to happen. But the main thing was, it wasn't going to happen to me. The day after I painted the door, I went off to buy new handles, so even if the door did shut I would be able to get back in.

"Remember not to close the porch door," I shouted on my way out.

"As if," called back my wife, meaning, of course, as if she would remember not to close the porch door, because that's exactly what she did.

About ten minutes after I left, my wife suddenly remembered she had to go out and, since it had started chucking it down, she was concerned the porch was going to get soaked. So she closed the door. I winced at this point when she later recounted her horrible adventure.

"Now hold a minute," she said, her eyes widening, "I'm not as daft as you think, you know. I didn't just close the door and hope for the best."

I waited to be convinced and was duly impressed.

Apparently, she had made sure she could open the porch door again by sticking her car key into the bolthole and successfully manoeuvring the snib – not when the door was closed, of course, that wouldn't have made sense, and not with the bolt which was still lying on the window ledge, but had somehow managed to make itself invisible.

"And do you know what?" she asked, hands now firmly on her hips.

I said: "Your car key wouldn't open the door when it was shut."

"How did you know that?" she demanded, but instead of waiting to find out how I knew the car key wasn't going to work she took me deeper into her nightmare of lock-out hell.

It was a weird and sometimes strangely wonderful story and if nothing else confirmed my belief that my wife is one of the most ingenious and determined people I know.

The reason she found out her car key wouldn't open the porch door so quickly was because the moment she closed it she realised she hadn't actually locked the main front door.

So there was nothing else for it, she just had to open the porch door, otherwise she would have left our cottage wide open for any passing burglar to stroll in and help himself.

The chances of this happening were as remote as our cottage, but, as my wife said, as long as there's a chance. This burglar was obviously going to be able to open the porch door a lot easier than my wife.

In fact, if he had turned up about half an hour into her reverse escape she probably would have been absolutely delighted to see him.

Thinking about burglars, her first move was to attempt to climb in through the top of the back room window, which was open a tantalising few inches.

There was a report a few weeks ago about a monkey that was burgling houses and pinching mobile phones. I doubt if even that petite felon would have been capable of such a tight squeeze.

Although, if he'd been around, my wife would have probably dropped him down the chimney, she was so desperate – particularly when she discovered her head and shoulders were stuck though the window and she remembered we had painted the window frame that very morning.

It wasn't wet, just tacky enough to give my wife a faint white chinstrap.

At this point, I would have driven to the nearest DIY shop and bought a pair of handles. Instead, my wife decided she could make her own. She said it came to her as she was trying to pull herself free of the sticky window. Actually, she landed on a clothes peg which she feverishly pulled apart.

She was smirking all the way to the porch door until she discovered the broken clothes peg still wouldn't fit.

Undeterred, she marched down to our summer house and, after failing to find a knife, started whittling away at the clothes peg with a pair of garden shears.

I had almost glazed over at this point, but her next brainwave pulled me back into the story with a look of stunned amazement.

Realising that there was little chance of her trimming the clothes peg with any accuracy, she began hunting around the summer house for anything that resembled a door-handle bolt.

She must have found something, because she paused for dramatic effect and that smirk was back on.

Obviously, I was meant to guess what she had found, but I was hungry and this was turning into an epic, so I gave up.

She disappeared for a moment and returned, proudly holding up a table-lamp.

Even with a wild and painful stretch of my imagination I couldn't see how a table-lamp could be deemed useful to your average burglar, not unless he needed to shed some light on the subject.

"The plug," said my wife, "look at the plug."

"Ah, right, the plug," I said, after a moment. Potentially, the plug's biggest pin could have passed for a door bolt. The problem was how to get the plug unscrewed without a screwdriver.

This is where our secateurs came in – briefly, admittedly.

Apparently, you can unscrew a plug with the point of our secateurs, which is handy to know if I ever get stuck for a screwdriver. Unfortunately, the small screws inside proved more of a problem. So my wife marched back up to the porch with the plug still attached to the table-lamp and shoved the big pin into the bolthole in the door.

When it didn't work, she whipped out her car key and slipped it in beside the plug pin. At which magical point, a country bus trundled passed and slowed down just long enough to allow its passengers an uninterrupted view of a crazed, half-painted woman breaking into a house with a rather chic table-lamp.

The moment she was inside the porch, the bolt made itself visible again and it was all my wife could do not to throw it out across the garden after the bus.

The main front door, of course, was locked all along. That goes without saying, because my wife is very security conscious.

Gone Swimming

WE WERE on our way to a nearby swimming pool when my wife decided it was time to lay her cards on the table. This was worrying news. As far as I was concerned, my wife didn't have cards to lay on the table. So my immediate concern was where these cards had come from.

"I'm afraid," continued my wife in her gravest tone, "there'll be no larking about. Or at least not from me."

I had to slow the car down to chew over that one.

"What, like ever?" I asked.

"When we're swimming," corrected my wife sharply, so I speeded up again.

I never imagined for one minute that my wife would be larking about when we were swimming; that's my job. My wife takes her swimming very seriously and methodically, almost like knitting – not that she knits.

What she meant was I would be larking about on my own, unless I made some larky new pals.

What else is there to do in a swimming pool but lark about?

"And there'll be no spitting, either," added my wife. "And no dive bombing, object throwing, petting, or smoking."

She couldn't remember the rest of the forbidden pleasures of the pool, but I got the message.

We were going swimming for the good of our health; if our spirits were uplifted in the process, then it would be a happy by-product of our focused physical endeavours.

After several failed attempts to lure me back to the swimming pool, my wife had finally convinced me it would do me the power of good. But she must have known secretly that I would get wet only for a laugh so, just in case I'd got the wrong idea, those cards had to be laid on the table.

"Right, no larking about," I agreed. Which, if she'd been listening carefully, sounded more like: "Yeah, that'll be right."

The swimming pool is part of a secondary school, so even driving into the car park put me in the mood for some mischief. This is the school the famous percussionist Evelyn Glennie attended and I bet she larked about in the swimming pool. She certainly seems the sort.

Needless to say, she wasn't there when we went. Nor were there any other men. I had the changing room all to myself and the pick of about sixty lockers. At first, I thought I would spread my stuff about, make the most of it, but I had only one 20p piece, so instinctively I went for seven, my lucky number, because you can never be too careful near water.

I was ready in a flash, but it took me ten minutes to figure out how to work my locker-key wristband. Once I'd mastered it, I was so pleased with the ingenious thing I played with it for another five minutes. Then I worried that it would come off while I was swimming because I had loosened it. I thought about changing it, but I needed another 20p piece, so I consoled myself that the office would probably have a master key if it came off and floated to the bottom of the deep end.

By the time I had showered and finally made it to the pool, my wife had done four lengths already. She thought I had done a runner after discovering I was the only man in the pool. So I confessed I had been playing with the wristband key.

"Thought as much," she said and bolted off to do another four lengths while I orientated myself.

Actually, I wasn't bothered in the slightest about being the only bloke; this just meant there was no competition. Apart from my wife, of course, who after regular swimming excursions had turned into Flipper.

There was one another bloke around, but he was a lifeguard, so he wasn't getting wet. He was far too busy entertaining the ladies with his boy-band mime and dance act along the poolside.

He was going down a treat and, to be fair, he was good looking, had some nice moves and the obvious advantage of being fully dressed for the part.

I don't remember dance music being played the last time I went swimming. It's not exactly an ideal acoustic and if your ears are full of water you can't hear it.

I kept thinking the ladies around me were about to launch into a synchronised swimming routine – eventually, the whole pool would be doing one big choreographed number with the lifeguards at the lead.

But that was just wishful thinking. Apparently, I had some serious swimming to do with my wife.

So I set off with good intentions doing the breaststroke alongside her, but after three lengths I was ready for the lifeguard.

There was a pretty blonde girl up on the high lookout chair at the halfway point, so I floundered miserably underneath her, sank a few times, swallowed a couple of litres of water and then floated on my back like a dead fish, but she wasn't interested.

Some kids had bumped into one another and suspecting the onset of some outrageous larky behaviour, she blew her whistle at them and almost gave me a heart attack.

My wife passed for the second time and told me to stay where I was because she was using me as a marker buoy, which suited me. I'd never felt so drained of energy and my shoulder muscles had turned to concrete.

Any larking plans I'd had were now long forgotten. So I just lay back, stared at the ceiling, listened to the wild echoing pop music and tried to come up with an excuse for my complete lack of stamina.

A woman shouting "arms high, arms high" at the top her voice fired me out of my reverie and made me put my arms in the air. I sank like a stone, convinced it was some kind of an emergency; the pool could have filled with arm-eating sharks for all I knew.

Back on the surface, I spotted the "arms high" lady shouting her orders at a little girl wearing inflatable waterwings. Maybe she was a contender for the Olympic waterwings event, but it all looked far too serious for me. I'd had enough.

When I told my wife I was bailing out, she just smiled knowingly and sped off like a torpedo.

Back in the changing-room, I remembered why I didn't like going swimming unless it was under the tropical sun. No matter how well you dry yourself after swimming, you're always worryingly damp and your clothes don't fit. It's as if your body has changed shape.

At least my wife agreed on this one. "You should try wearing tights," she said.

I don't know if that was meant to be advice or not, but it's as likely as me going swimming again with the dolphin lady.

The Case of the Cloven Feet

WE DO LOVE a mystery, particularly when it's in our own back garden. Most of the time, we have to search high and low in the nosy department to find something worth getting our deerstalkers on for.

So when we arrived home last week and discovered a great big mystery right across the bottom of the garden, my wife and I went into full Holmes and Watson mode.

We'd bought some heavy stuff, so we unpacked the car at the door and my wife went straight on the phone to a shop in search of something called the Chalcot Runner.

This is actually nothing more sensational than a type of long, thin hallway rug, but it sounded very exciting to me: "The strange case of the Chalcot Runner," I intoned to myself.

I could hear my wife spelling it out as I passed the kitchen window; obviously, the Chalcot Runner was also a bit of a mystery to the shop.

Down at the lower end of the garden, everything looked perfectly normal and blissfully serene. The thing is, you don't arrive home and think to yourself: I wonder if the garden is exactly as I left it three hours ago? Not unless you're seeing a psychiatrist. You just take it for granted that, flash floods aside, your garden will be one of those comforting constants in your life.

I say this in my defence because, for all my amateur sleuthing, I spent at least a quarter of an hour in the garden pottering around, going in and out of the summer-house, shifting stuff in and out of the garage, before it struck me that there was possibly something different about my immediate view.

But at first it seemed so subtle I thought I was imagining it. So I went back to the summer-house and looked across the redcurrant bushes to the little horseshoe apple orchard and, to my amazement, I had to admit that the garden, particularly the old vegetable patch, looked slightly odd. In fact, on closer inspection, it appeared to have been dug up.

I stood staring at it for a moment and then glanced around as I was going to catch a glimpse of some fleeing renegade gardener wielding his spade at me in mad defiance.

To be honest, he hadn't done all that good a job. The rhubarb was still intact, if a little on the crushed side, but the ground had been churned up and sort of rumbled around.

I was about to investigate further when I remembered my crime-scene training and took a careful step back and looked around for more evidence. It didn't take long.

The grass, which the heavy rain had softened, had been given the same corrugated treatment around my wife's car and under the apple trees.

We'd had a gardener in the week before to sort things out. He'd revealed the true scale of the garden and left it looking satisfyingly svelte, but now someone had turned up with a huge pogo stick and jumped all over it.

The ancient drystone dyke at the end of the vegetable patch, which had withstood at least a century of weathering, had also been knocked flat.

Obviously, it had provided an ideal springboard for pogo-stick man.

Either that or we had fallen foul of a phantom crop-circle maker.

Admittedly, they were a touch on the small side, but maybe they were

just tests, or a model of bigger things to come in the barley field across the broken dyke.

The pile of dung under the apple trees, however, put pogo-stick man and the crop circler on the back of a horse. How very rustic, I thought. Obviously, someone had ridden a great big horse round our garden, unless of course it had escaped.

Time to call in Watson, or Holmes, depending on who you want to believe. My wife did the same thing as I did – looked at the garden for a few minutes and then covered her mouth with horror.

"Flipping heck," she exclaimed, "please tell me you didn't rough up the garden?"

I shared my deductions with her about the big runaway horse and she began rubbing her chin and looking suddenly very suspicious.

"Hmm," she began, examining bits of broken twigs. "I think you'll find your horse has cloven feet."

She was right. So now we were in devilish Dennis Wheatley territory. My wife didn't think Satan worshippers were likely down our neck of the woods, but I reminded her about the people we had seen in the village hall one night, all in rows with their heads bowed while a figure on the distant stage chanted a litany of apparently random numbers.

My wife nodded along and in the end decided they were probably just playing bingo.

"Could have been a llama," I suggested.

"Or a giraffe escaped from a passing mobile zoo," chimed my wife sarcastically.

The thing is, you can't afford to leave a single stone unturned when you're dealing with a mystery – unless, of course, it's covered in dung.

"It's definitely cow dung," observed my wife, staring at the inert brown smear under the apple trees. I crouched down with her so we could both look like the dinosaur hunters in Jurassic Park.

After due deliberation, we came up with a scenario involving a huge escaped bull – the hoof marks were too small, we decided, for a cow and too deeply imprinted in the ground.

We retraced its crazed steps up our driveway and into the vegetable patch where it tried to escape by knocking down the drystone wall.

The farmer turned up now, probably with a gang of men to lure the maddened beast from its lair. Nets and ropes were possibly used, but the bull defied them all and sent the men flying as it drove headlong into the orchard where it paused momentarily to relieve itself.

There in the corner of the orchard, it must have been trapped, harnessed and then dragged kicking and snorting on to the road. And we missed it all.

Amazingly enough, all this had happened without scratching my wife's car, knocking a hole in the summer-house, or a single leaf being snapped from any of the trees.

We went out that night and told our friends about the escaped bull running riot at the bottom of our garden. A few days later, the local farmer's son turned up at our door.

"Come about the bull?" I asked, so he could look at me blankly. Then he smiled, shaking his head.

"It was half a dozen cows, actually," he said apologetically, "and it was my fault."

When I thought about it, six cows were better than one bull, so I wasn't disappointed in the slightest.

Apparently, the farmer's dog had been tragically trampled recently, so his son had taken its place while they were moving a herd up our road and things had gone slightly awry.

"You just can't get that kind of thing in town," said my wife later.

"Absolutely," I agreed, sighing contentedly.

Never Hurry a Murray

A WOMAN of an indistinct vintage who lives up the road from us was complimenting me on my anti-ageist policy.

"How do you find 'em?" she asked, "advert in *Saga* magazine?"

I had no idea what she was talking about, so I pretended it was top secret.

"Oh, I see," she smiled, tapping her nose, "keeping it to yourself, eh, very wise. If I had a crack crew like that working for me, I'd lock 'em up at night."

And off she went in a flurry of tweeds and yelping dogs.

Halfway up the garden steps, I was met by Murray the septuagenarian painter and decorator who was busy working on the exterior of the house.

The old stone steps are narrow and I tripped and crumpled to my knees.

"Aye, old age doesn't come by itself," he said, laughing away as he trotted nimbly past me.

It was then the penny dropped. The woman from up the road had been referring to our dad's army of tradesmen, the collective age of which must have gone into several hundreds. We hadn't made a conscious decision to exclude anyone without a pension; it was more of a herding effect, the common denominator being a thinning thatch of white hair and an unbelievable propensity for hard work.

"You realise that makes you Captain Mainwaring," remarked my wife, when I told her about the woman from up the road.

I had styled myself more in the role of Sergeant Wilson, purely because

I couldn't bring myself to order men around who were old enough to be my grandfather. Apart from having the welfare of a gang of pensioners on my conscience, I was seriously concerned about their toilet arrangements.

I kept offering up our own toilet, but there were never any takers. Obviously, going against the grain, they had bladders the size of swimming pools.

Finally, Murray the painter came to the door one afternoon in a very agitated state. At last, I thought, one of them has cracked.

"Come away in, Murray, the bathroom is over there," I said, pointing to the loo.

"Eh?" he shouted. "I've lost my hearing aid; I'm jist awa to look for it."

Two hours later, we had forgotten about Murray and his quest, so we were surprised to see him at the door again.

"Back for another look, Murray?" I shouted.

"I'm jist awa for my tea," he announced to the entire neighbourhood, "back later."

I walked him down to his van and asked him what the hearing aid looked like and he bent down and picked up a small piece of pinkish gravel, one of probably a billion or so that cover our drive to the depth of about six inches.

"A bit like that," he exclaimed.

I didn't have the heart to tell him that if he'd lost it a week earlier he might have stood a slight chance of finding it, but after a delivery of four tons of gravel the drive was once again rather more buoyant.

Feeling responsible, I started scouring the drive for the missing hearing aid. When my wife joined me, I was down on my knees in the twilight with the outdoor lights flickering to life. She suggested splitting the area into sections so we could carry out a methodical "scene of crime" search. After half an hour, I had an ocean of teeming gravel swimming before me.

"If Murray has found that hearing aid in his jacket pocket I'll brain him," I said.

"Sorry to disappoint you," came a familiar voice from the gloom. It was Murray with a dodgy old hearing aid in place, but at least he could hear us,

if a little faintly. We got our biggest torches out and approached the garden and the driveway in a three-pronged attack.

"The trouble is, it's nae much bigger than a peanut," said Murray, a comment that was to become something of a mantra. One of the neighbour's cats turned up to find out why there were three big animals down on all fours sniffing round its territory, so Murray got rid of it, in case it ate the hearing aid.

Then he stood up and said he had a plan. I was hoping it involved him going home and letting us off the hook, but apparently he had a secret weapon up his sleeve.

"When I moved into the hoose I'm in jist now, the previous owner had left something very handy in the garage," he announced. We stood there rigid with anticipation.

"Was it a hearing-aid-detector?" I asked weakly.

"Spot on," said Murray. "It was actually a metal-detector, but you were close."

We had assumed the missing hearing aid was made of plastic, but Murray announced that it was metal. There was, however, a slight kink in this ingenious plan: Murray had returned the metal-detector to its rightful owner five years ago, but he knew where the mannie lived and it was just a few miles up the road.

He left us staring at one another like zombies in the blaze of the garden spotlights. My knees and the palms of my hands were killing me; in fact, I had a feeling they might never regain their true shape as they were now pitted with dents after crawling around on the gravel for two hours. We were also both having difficulty straightening up, but we had another visit from Murray to look forward to and this time he was bringing a metal-detector.

"What fun," we chorused.

It was quite dark when he returned. It turned out the metal-detector needed more detecting than he thought. Undeterred, he slipped on the headphones and began scanning the driveway. Every two minutes, there was an exciting new find of a bent nail or an old screw, but no hearing aid. The woman from up the road passed right on cue with her dogs.

"Spot of overtime?" she shouted.

"Eh?" shouted Murray.

I told her we were sweeping for landmines and she laughed all the way up to the village.

The Frogs

I NEVER thought I would hear my wife say the sentence "So Joan has twenty frogs." It hung in the evening air, peculiar and somehow rather exotic, waiting for us to examine it further.

"That's quite a lot of frogs for one small pond," she continued as we walked through the village.

"Sounds like a serious collection to me; how does Joan know there are twenty?"

"I think she frogmarches them all out every morning for a head-count," I said matter-of-factly.

My wife was duly impressed, but remained slightly concerned because she has never been what you might call a huge fan of frogs, particularly the type I had just described. In fact, when I said they were as big as my hands and a slimy camouflage green, she shuddered and fell strangely quiet.

"With eyes like black glass beads," I added for effect, "that stared right back at you, almost questioningly, I thought."

My wife considered this scene for a moment.

"So how many did you actually see staring right back at you, questioningly?" she asked hesitantly, her moonlit face showing a temporary wince.

I said I had seen maybe a dozen, although it was hard to tell since the pond water was quite murky and full of floating plants.

"But at one point you would have thought the whole pond was just one giant frog," I added enthusiastically. "They were all jumping over one another and slipping off and sliding around."

There was a lot more of that kind of thing, but I was speaking to myself. My wife had been triggered into flight and I had been left walking alone down a delightfully-spooky, moonlit road that shimmered before me like a huge reptile.

In reality, my frog encounter had actually been slightly charming. I had heard them when I was standing at the door of Joan's gallery, the hard-to-pronounce Tolquhon, near Tarves.

For a moment, I thought it might be my stomach grumbling for its lunch because it's not often you hear a chorus of frogs in this country, particularly in someone's garden.

"That's our frogs you're hearing," said Joan, much to my relief.

"I didn't realise you kept frogs," I replied, all fired up at the thought.

"We don't keep them as such," corrected Joan. "They keep themselves in our pond."

"Low maintenance, then; sounds like my kind of pets," I mused as we walked down to the pond.

There was nothing to see at first, just a rather nice, larger-than-average-sized garden pond full of floating plants. The gallery sits on the crest of a hill, so I imagined the frogs must get a lovely view from this position.

Then one of them popped up, then another and before long at least a dozen of these large dark-green frogs were staring up at us, like spellbound princes waiting for the charm-breaking kiss to release them from their watery limbo.

If this was a fairytale fantasy film, all these frogs would have been visitors to the gallery that had fallen under Joan's wicked spell and I was probably her next victim.

This was probably how she lured you in, a nice little trip down to the bottom of the garden to meet the frogs and then, bam, you are in the water and there is an amphibian slithering all over you.

Word had obviously got out because more frogs now turned up to meet us. Some sprawled out, long-legged and lazy, while others huddled in dopey-

looking groups. Others just bobbed between the waterweed, trying to look coy and cute and, dare I say it, actually succeeding.

"They are strangely cute," I said, and Joan agreed.

Then, as if we weren't impressed enough, they spoiled it and started cavorting in what can best be described as a procreative fashion. Obviously, frogs have very high embarrassment thresholds, so we left them to it.

But they had obviously made quite an impression on me, to the extent that I reckon I must have been frog-tuned because, suddenly in the moonlit road in front of me, I saw one. Normally, I would have missed it and yet now in the half-dark it seemed quite obvious.

I called on my wife, who had the torch, and told her about my discovery, but she didn't believe me.

"Honestly," I shouted back. "It's a huge frog; it must be the season for them."

I reckoned it was probably between ponds and had been frightened by the torchlight.

"I'll have to move it off the road," I shouted to my wife.

"Well you can move it on your own," she called back. "I'm not a paid-up member of frog rescue."

I decided there was nothing for it but to run down and get the torch then bolt back before any traffic turned up and try to cajole the frog on to the safety of the verge. If necessary, I was prepared to pick it up, wearing one of my wife's gloves, of course.

But just as I reached my wife, a car came over the hill, drove straight over the spot where I had left the frog and sped past us. My wife let out a small scream and then we stood in silence staring back up the road, where apparently I had thoughtlessly left an innocent frog to fend for itself against a big evil car.

"Well that's probably the end of Freddie," announced my wife emotionally.

"Freddie?" I said. "Who the heck's Freddie?"

"Hopefully he didn't feel a thing," continued my wife.

A hundred yards on, my wife decided I had to go back and check on Freddie, so I did and took the torch with me. There was no sign of him, just

a small mound of freshly flattened mud where I had left him. Apparently, my frog-spotting expertise owed a lot to my imagination.

"Looks like he made it," I told my wife.

"Not one of Joan's, then?" she asked.

"Hard to tell," I said. "You know how it is: you've seen one frog you've seen twenty."

The Corduroy Car

MY WIFE didn't really have any trouble with her car until she realised it was a sort of vaguely glossy, actually more satin-finish phlegm green. Up until that moment, she was perfectly happy with it, because mostly she took the bus, basically because she likes company. Nothing to do with avoiding heavy city traffic, just sheer nosiness, apparently.

Then, one day a couple of weeks ago, the question just appeared out of nowhere.

"Do you think my car is a yucky green?" asked my wife as we were standing in the drive.

It was dark, so it was slightly difficult to tell.

"What makes you think that?" I asked, falling right into it, of course.

"You don't think it would look better pink or even black?" she asked.

"Well anything would look better than phlegm green," I announced.

"So it's phlegm green," she exclaimed. "Why didn't you tell me I've been driving around in a car that looks like a giant gob of phlegm?"

I wasn't sure how I got myself into this, probably by just being there.

I did the usual rewind thing and stated my case for having a car that

was an ambiguous green rather than a statement colour like pink, and that seemed to do the trick.

"So we'll get it resprayed black, then, excellent," said my wife, leaving me again wondering exactly how that came about.

I had a strong feeling I had been ambushed in my own drive; still, at least it had been short and sweet.

While I pretended to find a local auto spray shop – unlikely in the middle of nowhere – my wife took her catarrh car, as she had now dubbed it, to town, pretending that it was actually a car that she had borrowed from a friend, in case anyone asked.

Strangely enough, no one did. A few people, in fact quite a lot of people, pointed at her car, however. When she was at traffic lights, some kids banged on the window of their car pointing at my wife's car while pretending to be sick.

She called me from the car to tell me about this incident.

"Rude children," she exclaimed. "Imagine laughing at someone's car."

I said she must have been imagining things; they were probably laughing at something else, something my wife couldn't see.

"Like another phlegm-green car behind me?" she asked.

It wasn't impossible. The more we had talked about it, the more common they seemed to become, to the point where we began to think they were sending them up our way just to annoy us.

While we were on the phone, an old couple passed my wife's car and grimaced at it.

"Even old people don't like it," whined my wife. "It's definitely getting sprayed, bright pink."

The thought of having a bright Barbie-pink car in the drive was nothing compared to the phlegm-green crisis.

"Now there's a dog sniffing at the car," bleated my wife. I listened as she asked the owner to remove their dog, then someone shouted in a gruff voice: "Nae worries. He might catch something."

"What did he mean by that?" asked my wife.

I blamed it on rustic banter and told her I would paint the thing myself the moment she got home.

Actually I didn't need to, because it had been redecorated already.

I hadn't seen the car when my wife left; it was so dull it was almost dark, but it had brightened up enough for me to go out and pretend to do some gardening around her studio. She turned up in a flurry and pulled up sharp, just a few millimetres short of the apple tree she always parks under.

"Apparently, I've got a corduroy car," she announced the moment she jumped out, "or half a corduroy car."

I was baffled. From where I was standing, it looked pretty much the same to me, maybe a little splattered in mud.

"It's not mud," she said, arms folded as she gazed at her car.

Curious, I had a closer look and it turned out that the bonnet of the car and almost the entire passenger side was covered in what appeared to be the stubs of hundreds of panatela cigars.

"Someone's been using your car as a giant ashtray," I said, "probably a cigar smoker, lives nearby, possibly in the bushes beside your car."

"Giant toilet, more like," she corrected.

I moved hesitantly forward and took a tentative sniff. There was nothing in the aroma department, but I did recognise the toilet work. Unbelievably and disgustingly, it looked suspiciously like hedgehog droppings.

We adopted one from a sanctuary in Tayport a couple of years ago and now we have enough for a BBC wildlife special. In fact, we're expecting Bill Oddie any day.

When the original hedgehog arrived it was cute and probably wouldn't hang around long, we reckoned. My wife took to it immediately, but this was before we found out he was a mini-adventure hero and could climb granite walls, trees, fences and run like the clappers.

Sure, it kept the slug and snail population at bay, but it developed a nasty, despicable habit of doing the toilet over almost every exterior surface you could think of, including the garden table and chairs, the benches, the bird table, in fact especially the bird table – for a while, it was turned into a hedgehog midden. Even the wheelie bin, including the nice new one with the blue lid, didn't escape the attention of the hedgehog's rear end.

Then one evening this summer, we stepped outside into the garden and there was a furious scurry of all things spiny across the grass.

Nature had obviously taken its course and now the hedgehog had a whole family. More important, they were now *my* hedgehogs, like I kept them as pets and had names for them, took them out for walks.

"Well, I'm not going to clear up after them," said my wife.

Since there are no obvious clawing marks on her car, we concluded that the hedgehogs must climb up the nearby apple tree, roped together for safety, of course, and then drop their torpedo-shaped bombs en masse from the branches that overhang the drive. Quite an impressive stunt; not something you would like to attempt yourself, not in daylight, anyway.

I reckoned my wife should park her car the other way round so the hedgehogs could finish the job properly. At the moment, it looked like one half of her car was wearing an old brown coat. Either that or she could take the car out in the rain a lot, maybe soap it up beforehand. But neither option seemed to hold much appeal.

"So, corduroy," I asked optimistically, "is it dry-clean only?"

The Nuisance Caller

AS A THEATRE critic, I'm not allowed the luxury of making a nuisance of myself in public. I have to be on best behaviour, almost to the point of invisibility. I even contrive to scribble my notes as quietly as possible.

You would be surprised how noisy a pen can be to someone who is trying to concentrate on their favourite Abba tribute band.

Consequently, I'm always road testing pens in search of the quietest nib. Unfortunately, the best pen I've found doubles as a torch.

The nib glows with an eerie little green light that dances around like the fairy Tinkerbell when I start writing.

I've never had the courage to use it, just in case I alarm a member of the audience or, even worse, catch the eye of a performer on stage, put them off their stroke with disastrous consequences and end up under a headline that reads: "Critic closes play with a single stroke of his pen".

As a result, after years of persistent practice, I've developed the ability to write in almost complete monastic silence. This is a skill that will be familiar to anyone who managed to eat sweets in class without suffering the wrath of their teacher.

I had a Bunteresque school pal who could eat crisps like a ventriloquist, without moving his lips. He spent hours in his bedroom practising sleight of hand to get the crisps into his mouth, where he would silently suck the life out of them.

But if you've forked out hard cash for a theatre ticket, the last thing you're going to do is suck your crisps.

Even when I'm being ambushed by the sweetie-wrapper rustlers in the middle of a deadly serious play, professional etiquette won't allow me to jump out of my seat screaming. But I do sit smugly when the announcement goes out before curtain-up warning everyone to switch off their mobile phones and digital watches because, so far, I've survived without owning either.

During the interval of shows, rather than save money by speaking to the person they are with, everyone around me takes up the option to phone a friend. Meanwhile, I eavesdrop and become party to the fascinating lives of complete strangers. I can make up to twenty mobile calls on a good night, absolutely free.

One thing I've learned is that many men seem to be very forgetful when it comes to taking bread and mince out of the freezer. Many are also completely incapable of videotaping *Coronation Street* while they are watching a football match on another channel.

When the interval bell goes, the mobiles are normally switched off dutifully. Anyone who leaves one on during a theatrical performance is not just committing a gross social gaffe, they are declaring their novice status as a mobile-phone user and are therefore unfit to appear in public.

The next time anyone commits this heinous crime, however, I'll be

sympathising with them, because I know now what it feels like when the bell tolls for me.

During the recent opening performance of a contemporary dance company, my youngest son, Adam, joined me just after the second interval. He had been giving his own athletic performance at the gym and had decided that he would rather put up with forty-five minutes of modern dance than take the country bus home.

After pumping iron for several hours, he wasn't the coolest of customers. As he sat down beside me, I thought someone had switched on a big radiator.

When I handed him the programme – the piece we were about to see was enigmatically called *The Celebrated Soubrette* and I thought he might he like to know more about it – he started fanning his face and neck vigorously with it.

Consequently, the stout middle-aged woman next to him moved farther towards her husband to avoid the draught. Adam was in danger of blowing my cover, so I asked for the programme back, saying that I needed to refer to it for my review.

He informed me there was nothing in it as he handed it over, and the slightly ruffled lady next to him relaxed. The house lights went down and a blue spot followed a scantily clad female dancer to the front of the stage in complete silence. However, as she began posturing like a Las Vegas showgirl, a group of young children across the dress circle started giggling uncontrollably.

I was so relieved they weren't with me, particularly when a tutting of disapproval ran through the audience like Morse code.

Suddenly, the dancer on stage was being accompanied by a faint rendition of Beethoven's 'Fur Elise'. An interesting paradox, I thought, stroking my imaginary goatee beard. But then Adam became fiercely agitated, shifting in his seat and tugging at his bag on the floor. Adam had apparently set the ringer on his phone to the Beethoven piece, a wistful tune when it's played on a piano, but curiously sinister when it's performed on a mobile phone by the Sooty Braden Showband in the middle of a packed theatre.

As it dawned on the audience that they were listening to a mobile

phone while watching a semi-nude woman cavorting in front of them, you would have thought someone had set off a giant stink-bomb. A ripple of venomous dark looks shot towards us from the row in front and I dived for cover behind my programme while Adam strangled his phone furiously into silent submission.

On stage, the sexy cavorting girl was joined by her sexy cavorting boyfriend and the kids across the dress circle really let rip.

Meanwhile, Adam sat stony faced, frightened to move a muscle.

I was desperate to start writing my review, but I couldn't bring myself to reach inside my jacket pocket for my pen, so I decided to wait until the music started.

Eventually, the gigglers were either gagged successfully or lost interest in the silent proceedings and the audience settled down to working out what the heck was meant to be happening on stage.

An elderly chap across the aisle from me had given up and had fallen asleep with his chin on his chest.

Unfortunately, he was in for a rude awakening.

Suddenly, an electronic alarm clock went off full blast and the old chap jumped out of his skin, followed rapidly by the rest of the audience.

Once Adam had realised he was listening to his own alarm clock going off somewhere in the depths of his bag, he was on his feet struggling past me, muttering something about the button being broken and promising to buy a watch.

Even when he was out in the foyer, we could still hear it bleeping away.

There were raised voices, then the front doors opened and shut and all was peaceful again. Obviously, Adam and his clock had been turfed out.

Meanwhile, the stout middle-aged lady was staring hard at me for an explanation.

"Never seen him before in my life," I said, as someone behind me opened a big box of chocolates and let me off the hook.

Spooky

WE DIDN'T realise there were two queues pouring into the AECC, consequently we managed to join both, spreading ourselves out to block all those rude people behind us who we thought were trying to queue jump.

Eventually after a certain amount of anticipation we arrived at two doors simultaneously and a woman behind us asked her pals who Derek Acorah was, pronouncing his surname so it sort of rhymed with Baccarat.

"Did he nae sing wi Petula Clark?" asked one of her friends in reply.

"Dusty Springfield," said another with unflinching conviction. "He wrote songs for Dusty Springfield."

There was a long silence broken by the sound of a distant penny dropping somewhere very dark.

"Nah, that's the mannie fae the ghost programme," croaked a male voice.

"He gives me the creeps!" announced one of the women.

"Oh I ken fit ye mean," agreed the first woman who just a minute earlier had no idea who Derek Acorah was.

Then they were gone, swept away down a long corridor towards a memorable encounter with The Lord of the Dance.

"Maybe we should go there instead," suggested one of our party, obviously weakening at the thought of the army of spirit people hovering in the wings waiting for us.

Personally I find Irish step dancing far more unsettling and weird than any ghostly visitation and since I was reviewing Derek Acorah my interest was professional.

If he happened to pick on me then so be it, who was I to resist the call from the other side? I had an aisle seat in the front stalls and it was very possible Derek would be pointed in my direction by his spirit guide Sam.

After five series of the TV programme *Most Haunted*, Sam has now attained a level of celebrity in psychic circles akin to the non-celebrity Chantelle. Which is quite an achievement considering no one but his partner Derek has ever seen him.

Watching Derek going through his revelations about the various spirit energies he encounters with Sam is reminiscent of an episode of *Randall & Hopkirk*, except of course we can't see the one in the white suit.

It did look promising in the big hall though, where Derek was about to perform. On the stage there was a TV camera and a giant video screen showing a giant picture of Derek and a video clip of him being possessed by nasty spirits accompanied by waves of atmospheric electronic music.

None of which seemed to concern the audience in the slightest. In fact if it had been any different they probably would have been worried.

Everyone seemed to arrive without the slightest ruffle of excitement and quickly settled down, letting the tide of glittering, bubbling sounds wash over them.

They washed over us for so long we began to wonder if there was in fact another life beyond the spectral world of Derek Acorah. One by one we went to the toilet to check and returned with comforting reports of human activity.

Under the glare of the big lights my eyes then started inventing stuff to keep them busy. I could have sworn the giant portrait of Derek began to move and change shape.

When I mentioned this hesitatingly to my wife she told me not to worry because the photograph of Derek's face was in fact changing very subtly.

"How do you know it's really changing, maybe it's a psychic phenomenon?" I said, but my wife was having none of it.

Instead she decided to go to the toilet again, but as she stood up the lights went down and the gothic disco music kicked off, so she dropped back into her seat rubbing her hands with glee, in fact for some reason we all did.

The first thing Derek did when he took the stage was switch the music off and ask for the big bright overhead house lights to be put back on.

It was like your Dad turning up just as the party was about to start and throwing a bucket of cold water over everyone.

Within seconds the perfectly groomed Derek was down off the stage and it became clear why the lights had to go back on. Suddenly he was up on the big screen, larger than life in the midst of three rows of the audience all being projected in remorseless close-up.

You had to feel sorry for the lady with the large wart on her chin. If that had been me behind the camera I would have sneakily moved over a centimetre and cut her and her wart out of the picture, but no, there she stayed for at least fifteen minutes while Derek spoke to a stunned old lady who thought the microphone she was holding was meant to be a comforting lucky charm.

We never did find out if the bloke Derek brought to see her was her husband or the rent man because we were all too busy wondering if the woman two rows behind knew she had a moustache or where the woman in front had bought her lovely brown jacket.

There was an older chap in the middle of all this who was trying to sink down in his seat so he could scratch or pick his nose, but there was no escape.

All I could think was, "Oh please don't let him come over beside me", and then of course he did.

I had already started writing about the show so I froze in mid-sentence as Derek decided to stop right beside me and speak to a couple I assumed were in the row behind.

I was scared to look up at first but in the end I couldn't resist it. Thanks to my new reading glasses all I got was a delightfully soft focus version of myself which I deemed to be far more acceptable than I had feared, thinner, younger even, considering my mug must have been about five feet high.

I was right on the edge of the screen so unfortunately no one else in our party made it to the big time.

Once you've seen yourself like that it's hard not to give the occasional glance and focus your entire mental attention on what the rest of the audience are possibly making of you.

Derek and his spirit visitors had by this time faded into the background. Meanwhile all I could do was thank my lucky stars I didn't have any noticeable facial blemishes.

Then a strange thing happened that for a moment made the hairs on the back of my neck stand up – I removed my specs and cleaned them while still wearing them.

"What made you think that was you on the screen?" laughed my wife at the interval, "That chap behind you was half your age."

I blame Derek Acorah; people start seeing strange things when he's about.

Taxi!

AS SHE looked up and down the line of black cabs purring outside Glasgow's Queen Street railway station, my wife said: "When you think about it, you should be able to pick the taxi you fancy."

"The best-looking one?" I asked.

"The smartest and cleanest," replied my wife. "A brief internal inspection would do the trick."

"Maybe you should interview the drivers as well, just to be on the safe side," I suggested.

Right on cue, the driver of the first cab in the queue wound his window down and treated us to a sample of his jocular urban banter.

"Yez gettin in, or are yez waitin for a better offer?" he shouted with a voice like a big rasping metal file.

"I think he means us, your ladyship," I declared. "Allow me to get the door for you." My wife jumped into the cab and bade the driver a hearty good afternoon.

"Aye, so it is, hen," he replied. Then, after clearing his nasal tubes of catarrh, he responded to a brief crackle on his radio with a fiery double-barrelled expletive.

"Useless manky dobbers," he added under his breath. "So where's yooz goin?" he croaked.

Eager to get on our way, we announced the address almost in unison; I think we were probably about a word behind one another.

"Is that one place?" rasped the driver, wheeling his head round and revealing once again a face only a mother could love.

We both tried to say the address again, but it came out in a tangled chorus.

"If you don't mind," began my wife, "since I'm originally from Glasgow and we are actually visiting my relatives, I think I'm perfectly qualified to tell the driver where we'd like to go."

"Except that I've got the postcode," I replied smartly.

"Well, we're not being posted, so I don't think we'll be needing that," returned my wife.

"Look," shouted the driver, "I don't care who tells me. Where are yez goin?"

I was so startled I missed my cue and my wife got in before me, clearly announcing our desired destination in Newton Mearns.

"Newton Mearns," shouted the driver, "does this look like a train?"

We chuckled away in the back like a right pair of "dobbers".

"This is a Glasgow city cab," shouted the driver, "no a bus."

"Or a train," I added, and got a dig in the side from my wife.

"Is there a problem with taking us to Newton Mearns? It is actually a suburb of Glasgow; it's not on the moon," said my wife as if from a great height.

Apparently, it might as well have been on the moon because it wasn't within the Glasgow city limits and we would have to get out and make other arrangements.

Ever compliant, I made a move for the door, but my wife grabbed my arm.

"That's not going to happen," she declared, suddenly speaking with a broad

Glasgow accent. "We're going to pay you to take us to Newton Mearns; that's the universal law of taxis. Now can we get moving."

Suddenly a horn blared out. It was the cab behind, which had loaded up with passengers and was obviously raring to go. The horn blared out again and our driver punched his head out the window and told the driver behind very loudly to do rude and impossible things to himself, then he asked another driver who was about to get into his cab how to get to Newton Mearns.

Somehow he had never heard of it. Our driver looked round and shook his head at us as if we were seriously wasting his time.

"Sorry to be such a nuisance," said my wife. "We do this all the time, it's our hobby, sitting in taxis outside train stations."

Now there was a chorus of horns blaring behind us. There followed a brief exchange of high-quality insults and suddenly we were off. Within seconds, we were being driven along George Square by a sweary wee Glasgow mannie.

"This is OK," said my wife quietly as she made herself more comfortable. "We're actually going in the right direction."

A few minutes later, while the driver cursed at an innocent cyclist, I remembered the delightful stress-free train journey we had just enjoyed, drinking coffee and reading magazines and books, pointing at the scenery and generally having a jolly time.

"I'm glad Glasgow belongs to you," I said to my wife, who was now studying the AA directions I had printed out. She handed them to the cab driver when we stopped at the lights; he gave them one cursory glance and then discarded them.

At the next set of lights, we drew up alongside another cab and our driver asked for directions. When they were unforthcoming, a stream of curses followed and then we were off again on a hunch. I could feel my blood pressure rising and I untied my scarf.

I recommended another look at the AA directions, but apparently they were a complete waste of paper, so I suggested to my wife that it might be an idea if we just got another taxi.

But that really did it, because the driver overheard me and he was going to

make it a personal point of professional honour to get us to our destination if it killed him.

"Hopefully it won't come to that," I said.

He then spent the next few minutes swearing into his radio and again cursing at other drivers, particularly those with oddly-shaped heads. He took a few moments to point these out to us.

In the end, we had to be talked in to our destination on the phone by one of my wife's cousins. As a sort of encore, as we arrived, my wife decided she needed a drink of fizzy mineral water. When she opened the bottle, the water exploded over the driver who had turned up at the door to help her out.

Thankfully, we all laughed until the driver insisted on coming back for us. It was the least he could do, he said.

Bird Brain

THE alarm had just gone off like some mad metal lunatic tearing round our bedroom, smashing up a banjo. It does the same thing every weekday morning, but it still almost kills me.

You would think by now that someone would have come up with a device that would guarantee a gentler awakening. I suppose that's why people who could afford such luxuries had a butler.

I was lying there half awake, mulling over the delicious prospect of being stirred by a coffee-wielding servant and hoping my wife would fulfil that role, when I dozed off again.

It was nothing too serious, just a light whisper of a sleep, because there was a whirring noise close to my right ear that was daring me to sort it out.

I woke up enough to wave a hand in the air and inform my wife that the alarm had gone off. She reminded me she wasn't deaf, but she said nothing about the annoying whirring noise that was back around my right ear.

If that's a fly, I thought, it must be some size.

The whirring noise went off to disturb other parts of the room and I felt myself slipping back into the abyss of sleep.

Normally, this is when I'll have a sharp word with myself, throw back the quilt and swing my legs out of bed. We have a wooden floor and it's freezing in the morning, so that always helps.

But instead I was forced to round up my fudgy senses because something was sitting on my head. It wasn't very big, so if it came to it I could have lived with it and gone back to dreaming about the little helicopter I had found at the back of a cupboard.

But whatever it was, I knew instinctively it shouldn't have been there and it was slightly uncomfortable. Then it really hit me that something was on my head. Sitting bolt upright with a yelp, I rubbed at my hair with both hands and a little bird flew across my face.

As alarm clocks go, this was certainly unusual, but highly effective, nevertheless. It certainly worked wonders with my wife. No sooner had I announced there was a bird in the bedroom than she was up out of bed and running on the spot.

It was impressive stuff. Still running ten to the dozen, she bolted round the bed and tried to get in beside me.

But the bird headed her off and she was caught for a moment going in two directions at once until she made a dash for the door.

She was out in the hallway with the door slammed hard behind her, but I could still hear her running on the spot and making a horrible low wailing sound.

This was a bit of a worry. The bird careering around the room above me was bad enough, but it did cross my mind that maybe there were more birds out in the hallway. For a few nasty surreal moments, it was all too Hitchcock for 7.30 in the morning.

"Are you all right?" I shouted, ducking and closing my eyes as the bird dive-bombed my head.

"Of course I'm not all right," screamed back my wife. "There's a bloody bird in the bedroom."

I told her to go and hide in the bathroom and then, as an afterthought, asked her to switch on the kettle.

"Just get it out of the room," she shouted back and then ran off to take deep cover behind the shower curtain.

Quite why it should be my responsibility I had no idea. True, I had rumbled the bird in the first place, but I had no experience or special talents in the bird-rounding-up department.

I was also dressed inappropriately for the pecking season. So while the bird darted about the other corner of the room, I sneaked out of bed and grabbed the first thing that came to hand.

I probably looked a bit of a cross-dresser in one of my wife's long winter coats and an old wide-brimmed straw hat, but I felt a lot safer.

Quiet what was going to happen next was anyone's guess.

"How are you getting on?" shouted my wife from the bathroom.

I told her we were getting along swimmingly and that the bird liked our house so much it was moving in permanently, but there was no reply.

The bird meanwhile had decided to catch its breath and weigh up the situation while perched on top of the bedpost just a few feet from me.

This gave me time for a close look and to discover it was, in fact, a wren. The size and short tail is always a giveaway.

Apparently, there are 1 million self-confessed birdwatchers in Britain, but there are probably very few of them who can enjoy their hobby in the comfort of their own home – not with a wild bird, anyway.

It was certainly very cute, but an absolute menace because it just wouldn't stay still for more than a few seconds and kept making a beeline for my head. Then it disappeared into the little library room that adjoins our bedroom.

It had obviously flown in through the open window in that room, so I closed the door behind it, hoping it might have the decency to fly back out the window.

I listened intently as it fluttered around for a minute then everything went quiet.

I toyed with the idea of leaving it to its own devices and going to work,

but what if it didn't fly out and instead did its business all over our books? Knowing our luck it would be waiting for us when we came home.

There was nothing for it but to venture into the little room and be flapped and pecked at. Just to be on the safe side I grabbed a pair of sunglasses, put them on and opened the door warily.

By now, I must have looked like some old loopy rock star in my big coat, shades and wide-brimmed hat, but that was the least of my worries. In fact, I was worry-free because, as far as I could see, the bird had gone. The sunglasses didn't help, though, even with the light on.

I breathed a sigh of relief, turned round and saw the bird perched back on the bedpost.

I decided the only thing to do was to run round the room flapping my arms like a big daft bird in the hope of persuading the wren that he had huge unwelcome company.

To my amazement, this worked and the bird flew like a bullet into the library and out the window.

"Never mind," consoled my wife, "it's not every morning you wake up with a wren on your head."

I think there's a Carry On joke in there somewhere.

BFG

MY WIFE had made some of her famous soup. She called it winter fuel. Thick and laden with fresh vegetables, you could have cut it with a knife. She made a month's supply and stashed most of it away in the freezer, leaving a generous stock in the fridge for my daily consumption.

Quite honestly, there was nothing in a supermarket that even came close to its substance and flavour, but it was extraordinarily dense. In fact, my spoon stood up in it and it was impossible to dip my bread into it.

After just one big bowl, I felt as if I couldn't have eaten anything else for a week. Actually, I wasn't far wrong.

Later that same day, I found my wife rummaging in the fridge. "What's happened to the soup?" she asked, her head stuck in the lower compartment.

I told her I'd eaten it and that it was out of this world, better than any soup I had ever tasted in a restaurant. I thought she would be pleased, but she was alarmed.

"How do you feel?" she asked, standing up slowly.

"Never better," I smiled. "I'm raring to go."

"You'll be raring to go all right," she laughed, "The soup should have been diluted; you've eaten about four days' worth."

I assured her I had no ill effects, but she fell silent and took several steps back. Obviously, she said, I had forgotten what had happened the last time I over subscribed to her famous soup.

"But it didn't make me ill," I insisted.

"No, but it made everyone else ill," she declared.

She was right; I had forgotten why my wife was always so reluctant to dish up her celebrated cheese-hard soup. She had relented only because I'd had a cold since September.

But it was all coming back to me now like a bad dose of indigestion. It was two years ago. I had eaten a bowl of the home-made soup before getting on a plane. It was the worst flight of my life – in fact, it was the worst flight of every passenger on that plane's life.

As we took off, I suddenly felt as if I had swallowed my life-jacket and it was self-inflating inside me. I sat bolt upright as the pain shut around my stomach like a vice then tried to muscle its way up through my chest, changed its mind and headed south.

At first, I assumed it was a reaction to the change in air pressure and that it would sort itself out. When it didn't, I tried to wriggle it out of me, but it was stuck above my safety belt like a huge aching bubble that was growing by the minute.

So I tried to force it back up again while swallowing hard in an attempt to produce what I hoped would be a rather small burp.

Meanwhile, the bloke beside me did his best to concentrate on leafing through his in-flight magazine.

As I pushed harder into my stomach and jerked backwards, he must have wondered what I was up to, but he had managed to find an engrossing article about Doulton figurines and was quite happy to let me get on with it.

At last, the sign came on telling us to undo our safety belts. It was the worst thing that could have happened. The enormous nasty balloon I had been brewing slipped free and found its natural exit.

It was so delighted to escape that it ruffled the top of one my socks on the way past.

The whole thing was completely outwith my control. It was as if I had been possessed and then all of a sudden exorcised.

There was certainly something seriously demonic about the aftermath. In fact, it was all I could do to stay in my seat. The bloke next to me froze over his magazine, staring at a full-page photograph of a delicate Doulton ballerina, while I tried staring out of the window into the pitch darkness.

And that was pretty much the style of things for the rest of the flight. I tried to stay in the loo for as long as I could but, in the end, I had to give up because I needed some air.

Fortunately, one half of the plane was empty and after a while I was sitting in it, like some naughty smelly boy banished to the back of the class.

When I left the plane, one of the stewardesses gave me a sympathetic goodbye, but her pal just glowered at me.

I went red remembering that ordeal and couldn't understand why my wife had made her famous flatulence-inducing soup again, or why she had left me enough to power me into outer space.

"Best place for you," she warned. "Just as well you're going out tonight."

This was good news for my wife but not for the hundreds of people who would be sitting around me in the theatre trying to enjoy the stage version of Roald Dahl's *BFG*.

I said in my review of the show that the letter "F" in *BFG* did not stand for "friendly", it stood for "flatulent". It was a classic case of life imitating art imitating life, if you know what I mean.

I'd forgotten about the giant's penchant for noisy wind-breaking, but believe me it was a blessing in disguise. The giant's favourite tipple has gas bubbles that go down the way; I knew the feeling. So instead of flying out of his mouth in the form of burps, they blew out the other end aided by a loud and long sound effect that finished with the noise of a cork exploding from a bottle.

I didn't need sound effects, but they were the ideal solution for my problem. I felt sorry for the couple sitting in the row in front of me and my son Richard, who had accompanied me under duress, but I couldn't think of an alternative.

If I bolted outside every five minutes, I would disturb the entire house and miss half the show. So I just waited until the giant was ready to let one of his whizz-poppers go, as he called them, and I went with him.

Suddenly, programmes were being fanned all over the dress circle.

Later in the car, as I drove Richard back to his flat, I had to own up. Richard laughed to himself, but was disappointed because he thought it was part of the show – a specially concocted smell-effect; which in a way it was.

I was glad I had confessed, because my parting shot sent Richard flying from the car into his flat.

Unfortunately, it followed him inside like an invisible stalker. I had to turn the car at the top of his street and when I passed by again Richard's two flatmates were running out the door, followed swiftly by Richard protesting his innocence.

Apparently, they wouldn't let him back in for half an hour. If you're looking for absolute privacy, there's about three weeks' worth in our freezer.

The Family Jewels

IT TURNED out it was an old VHS tape that was jamming the drawer in my desk. By executing a series of shunts and shakes, eventually it relinquished its hold and within seconds the month-long siege was over.

Unfortunately, you can't negotiate with a desk, so this was a rare moment of human will triumphing over the unequivocal silence of the inanimate.

I actually grunted "gotcha" as the drawer flew open and the tape tumbled forward.

"You should be ashamed of yourself, James Bolam," I said, staring at the benign actor as he gazed smiling at me from the VHS tape box, dressed in the uniform of a postman. I had only the vaguest recollection of this tape. Someone, I reckoned, had loaned it to me and I had thoughtlessly stuck it in this drawer.

Rather appropriately, it was called *The Missing Postman*, and obviously it was still missing from someone's video collection.

From the description on the back it sounded quite promising, so I took it to my wife and presented it as if it was the Ark of the Covenant.

She stared at it and announced that, as much as she liked James Bolam, it wasn't really what she had pictured when I told her that the drawer had been jammed shut by treasure.

"But it could be TV treasure," I pointed out.

Fortunately, we still have a VHS machine welded into our HD time-slip enhanced DVD combo. We have a few old family tapes that we use to embarrass our children; there was one in the machine that we had been watching dewy-eyed the previous evening.

This irreplaceable videotape which we've guarded through several house moves was used for about six years to build a record of our sons growing up. If you fast-forward it, they sprout before your eyes like inflatables. It's packed with memories, like, for instance, Adam's first primary school concert, which he introduces from our sofa in the style of a BBC *Proms* presenter.

Later on, there's eldest son Richard's first gropings into the field of film noir, a horror movie shot in his bedroom featuring his brother being eaten by an easy-chair.

As it turned, out *The Missing Postman* was no substitute for Richard's home horror movie. After just five minutes of this nugget of TV gold, I was falling asleep. Which was odd, because it didn't mention this on the cover of the tape.

So naturally I did what everyone else does when they find stuff they borrowed years ago from people; I put it on the internet for sale.

You can imagine my delight when I discovered the tape was in fact a genuine piece of TV treasure, quite rare, in fact. Even better, it sold that same afternoon and I caught the last post with a look of contented smugness.

"Oh, thanks a lot," said my wife, "I was looking forward to seeing that programme."

"But it was pants," I replied.

"Well it would have been nice to have been given the opportunity to decide for myself whether or not it was pants," she said brusquely.

I suggested buying the tape back to prove my point, but my wife thought it would be a better idea if I went off and boiled my head.

I consoled myself with my ill-gotten gains and a desk drawer that was now back in action.

Three days later, I received an e-mail from the bloke I had sold the tape to. It was brief and curiously enigmatic.

"Tape arrived today. Tell me, does Adam still play the violin?"

I was taken aback at first, but eventually it dawned on me that I had obviously sold the tape to a friend of one of our sons, so I replied giving them a brief update.

"Hi, you'll be pleased to hear that Adam is now a professional violinist and a violin tutor; I'll tell him you were asking for him. Are you an old school friend?"

I had to wait until the following day for a reply and in the meantime I kept quiet until I had all the facts.

"No, we're not old school friends," read the reply, "but we enjoyed the school concert very much, although we felt the 'Blue Danube' was a trifle rushed."

I doubt if I could have been more baffled and I sat there staring at the computer screen like Dumb and Dumber's half-daft brother. However, the next sentence revealed the true depth of my stupidity.

"Also, there doesn't appear to be any sign of James Bolam on the tape, or his co-star, Alison Steadman. Any idea where they might be?"

Right on cue, my wife turned up in the doorway of my study.

"I thought you said you had sold *The Missing Postman*?" she began. "Anyway, you were right; it's not very good, is it?"

Intrigued by my look of mute amazement and my wobbly finger pointing at the computer screen, my wife approached with caution and read the e-mail.

"You twit," she shouted, "how did you manage to sell someone one of our family tapes?"

I had been asking myself the same question. Obviously I hadn't thought to check the tape box before sending it off.

"Well you'll have to get it back," shouted my wife, "I don't want complete strangers watching our life."

"People do it all the time on *YouTube*," I replied.

"You're a tube," blurted my wife and poked me in the arm just to make sure I knew it was me that she meant.

When I mentioned the videotape fiasco to Richard, now a man of thirty-one, and related how the unsuspecting buyer had sat through Adam's concert in the belief it was possibly an introduction to the TV programme, he looked unexpectedly glum.

"I'll bet they didn't watch my horror film," he moaned.

"Oh they did," I lied, "but they couldn't understand why James Bolam wasn't in it."

That made him laugh.

Anyway, we have our very own likely lads on tape, lately returned safe and sound after a brief but memorable sellout tour.

The Sitter

I SUPPOSE at some point while I was busy being suitably distracted I must have agreed to sit for my wife's oil painting class and have my portrait painted, but I don't remember actually saying yes, not wholeheartedly, not with boundless, can't wait, enthusiasm.

Having a portrait of myself, or to be exact half-a-dozen portraits of myself, is not particularly high on my ever-diminishing list of must-have lifestyle accessories. Like most people I have only the vaguest notion of how I appear to others and I'm not in any hurry to have my worst fears confirmed.

On the other hand, I think everyone should have a portrait in their attic like Dorian Gray that ages and bears the scars of everyday life while the subject strolls around in a blissful state of perpetual youth. I'm convinced my wife has one of these spellbound portraits hidden in the loft and it seems to work for her so I thought it was worth giving it a go.

In any case, it sounded like a total skive. If pushed I could easily lounge

around for a couple of hours, maybe if I was sly enough I could even fit in a nap.

I was actually looking forward to it and had relaxed into the idea until the day before the first sitting – there were two sessions, when I was overtaken by a mild flurry of pre-portrait panic.

What happens if I don't look my best, I thought, although who's to say what my best is, if indeed I ever have a best. And what about my hair, a question I often ask but never really have a satisfactory answer for.

These were big issues, but not as big as the question of what to wear. Fortunately my wife had the answer.

"Just wear the same clothes for both classes," she said flatly.

I was already on to the whole continuity thing but it was good to hear we were both on the same page.

"So what about background?" I probed. "Anything in mind, something dramatic perhaps, masculine but interesting? And what about a pose, do you want me to make a particular expression?"

My wife was busy painting while I was interrogating her so I don't think I got her full attention.

"Just make your usual glazed-over, vacant look. That'll give everyone a nice blank canvas to work with," she said without glancing up at my usual glazed-over look.

I could see her point. There was no point in looking too interesting, moody or dramatic because there was every chance I wouldn't be able to sustain it. I'd have a break to stretch my legs and come back with a completely different expression.

So I went off to the bathroom mirror to practice looking vacant or at least semi-vacant. I didn't want to be set in oil paint for eternity as a complete numpty. Then I hit upon the idea of reading a book, the scholarly look appealed to me and it would give me something to do for two hours.

Five artists turned up to my wife's class at the village art studio, four women and one man and all of them seemed reasonably amused at the prospect of painting my portrait, although they were perhaps a little too amused.

"I hope I've brought enough paint," declared one of them. "I hope you're not easily offended," remarked another, and another.

I didn't like the sound of this, but I lied anyway and assured them that I was completely unconcerned about how they portrayed me. "I'm insult proof," I said cavalierly.

"Just as well," said someone and they all laughed.

By this time it was too late to make a run for it. My wife had arranged everyone around me in a U shape so that I looked as if I had been caught and was about to be interrogated. Actually it was worse than an interrogation, even before they had made a mark I had six pairs of eyes, including my wife's squinting and staring intently at me as if I had arrived from a distant galaxy.

One of the women measured me holding her brush at arm's length and announced without any shadow of a doubt that I had a perfectly square head.

I took immediate issue with this and was told that I wasn't allowed to defend myself, I had to shut up and stay perfectly still while every millimetre of my face was inspected. There was also no question of reading my book, not unless I could hold it in such a way that my head remained upright.

I tried it for a minute just to be awkward but my arms turned to lead and the book was silently removed.

Just when I was ready to give myself up, every kid in the village arrived outside the studio window like Stephen King's *Children of the Corn* and decided I was their entertainment for the evening.

Since I was facing the window, I was the sole audience for their grotesque performance, which became more outrageous the longer I remained utterly expressionless.

Eventually, my wife relented, swiftly closed the curtains and gave me a row for encouraging them.

And then the acute artistic observations arrived.

They started with "do you think his eyes are too far apart?" then I had too much hair, which I was rather pleased to hear, but then I had horribly thin lips and a nose like a broken beak. With my perfectly square head, I wasn't having much luck.

"Excuse me!" I said. "This isn't a portrait class, this is aversion therapy for the chronically self-infatuated."

But apparently they were discussing their individual paintings, or so they said, but I had my doubts. My wife meanwhile relished every minute and tried her best to hide her smirk behind a mask of tutorial professionalism. But every so often I caught her congratulating herself for having such a brilliant idea.

After two hours, even with a couple of breaks I couldn't have cared less if I turned out like the *Phantom of the Opera*. I'd hit my glazed-over vacant stride and I had gone somewhere else far, far away, probably back to my home planet.

Although this was only the first sitting I have to admit I couldn't help examining the results. Rather intriguingly each artist had caught a different aspect of me, so that lined up I looked like some master of disguise, arch criminal or the FBI's top five Most Wanted.

I decided I didn't need a Dorian Gray portrait in my attic; they were all right in front me with everything life had thrown my way captured in glowing colour.

Actors say you have to give yourself up in order to find yourself. I reckon I did just that, the trouble is, I'm not sure what to do with what I've found.

The Mystery Guest

APPARENTLY, face blindness is all the rage. People can now walk straight past friends and family in the street without fear of being deleted from their will, because they have a bona fide condition that prevents them from recognising anyone they haven't met in the past ten minutes. In extreme cases, this is shortened to ten seconds. I've had a mild form of it for years, but normally get round it by asking oblique, open-ended questions. Quite often, though, I can give the game away before it has even started.

The amiable bloke who approached me recently outside a theatre during the interval of a show must have seen through my look of faux recognition as I greeted him.

I was deep in thought about my review when he appeared and stood next to me.

"Decent enough production," he said.

"Not that I'm trying to put words into your critique," he added, making the word "critique" sound like a sacred scroll.

"Suggestions are always welcome," I said, smiling at him and failing completely to recognise him. It was odd because he acted as if we had known one another for years.

"You probably don't recognise me in civvies," he said, smiling back.

"That's an occupational hazard, I would imagine."

We laughed, but I was trying to work out what else he would be wearing if he wasn't in a jacket and tie. He bore a slight resemblance to a joiner who

did some work for us a few years ago. I supposed he could have gone bald and decided to adopt a Donald Trump sweep-over hairline.

"My wife keeps telling me I'm not very good with faces," I said.

"I've heard it could be hereditary," said the bloke.

He had a point. My father – who was at sea most of his life – once insisted that film star Gregory Peck was in *Crossroads*, the TV soap. Nothing could convince him otherwise.

"They must have some budget before they can afford him," he said.

"Been busy lately?" I asked my new old friend.

He took a long, slow intake of breath and shook his head.

"Not since the accident," he replied gravely.

This presented quite a problem. Had this accident happened to him or to a member of his family? It certainly sounded serious but, being clueless, I blundered on.

"Of course," I agreed, nodding, "must have been very difficult for you."

"It was, and I don't care what anyone says, compensation is no substitute for a job," he said, looking at me darkly.

"I can imagine," I lied. I couldn't imagine what that compensation might have been for. Then he brightened up.

"To be honest, there's no comparison," he said and we both laughed.

"Actually," he continued, "I was thinking about starting up my own company."

"Good for you," I replied, "would you call it after yourself?" I added, hopefully.

He laughed and said it would have to be something more dramatic. He had an unusual name – as I knew – so he didn't think it would sound right.

"Absolutely," I agreed, "something more dramatic."

We fell into an awkward silence, which I determined not to break because I was hoping he would suddenly remember he had to be somewhere else, like the theatre bar. Then an acquaintance that I did recognise turned up and fortunately they introduced themselves to one another.

The strange thing was I didn't recognise the bloke's name at all and when the acquaintance left I was very tempted to go with him, but I was somehow

magnetised to this bloke. He wasn't particularly threatening. I just had a feeling something else was on the horizon, something that I wasn't going to like.

"This must be the second or third time you've reviewed this show?" mused the bloke. "The last time, of course, you didn't think too much of the male lead."

This was news to me and I said as much.

"A 'gallant performance' was how you described it," continued the bloke without missing a beat.

I couldn't honestly remember and the word "gallant" didn't sound like an expression I would ever use.

"Let's just check, shall we?" said the bloke.

I knew what was coming next, but even as he pulled the newspaper cutting from his inside jacket pocket I was hoping he would burst out laughing and point at me saying something like "Ha ha, got you".

But he didn't. Instead, he unfolded the cutting carefully, produced a pair of specs and read the word "gallant" out loud, then my name. "Guilty as charged," I said, laughing, "have you got any more?"

"How long have you got?" asked the bloke with a poker face, then produced a second, much larger cutting.

"This one always baffled me, and I quote: 'There was nothing the lead man could do but sing boldly for his supper.' That's a queer one, isn't it?" he said, then repeated it.

I had no recollection of writing that, either, so I took the cutting from him and read it myself. It was a six-year-old review of an amateur production in which the lead male role was played by a bloke with a very unusual name.

"So this is about you?" I asked.

"Who did you think it was about?"

Before I got a chance to answer, I was saved by the bell – or so I thought.

"I couldn't help noticing you have an empty seat next to you," said the bloke. "Would you mind if I joined you? I'm sitting off to the side and the view's not great."

Resistance would have been futile, perhaps even childish. In any

case, we would be sitting in a packed theatre, but then so was Abraham Lincoln.

Once in our seats, he made himself comfortable and then he waved to someone as the curtain was going up. On the far end of the balcony, a woman with red hair and a red face was grinning and waving back enthusiastically.

"Right, now," said my new pal, "where were we?"

The Plumber's Mate

I DON'T know what kind of trouble he was expecting, but the plumber was wearing safety specs when he arrived. Maybe our innocent little porch looks dodgy, but he seemed to be ducking from something, so I started ducking as well, just to be on the safe side. I also looked over his shoulder in search of a van, so he looked over his shoulder as well and then back at me, ducking.

At this point, I didn't know he was the plumber because I was still waiting for him to introduce himself. He was holding a piece of paper which he glanced at occasionally between squinting at me through the safety specs, bobbing up and down and looking over his shoulder.

We could have been trapped for some time in this routine if I hadn't blurted out the word "plumber."

"Come to replace our bathroom taps?" I continued, giving a little swerve just for good measure.

"That's it," he ducked back.

He left a box in the vestibule, which I carried in assuming it was our new bathroom sink taps.

When I came back, he was heaving an enormous box through the front door. It was at least a metre long and looked very like the sort of thing that

would knock great divots out of the corners of our walls. But it was the plumber's big muddy boots I was really concerned about.

"Would you mind taking off your boots?" I asked.

The plumber laughed, adjusted his safety specs and began lifting one muddy boot nearer the hallway.

"Just leave them in the vestibule," I added smartly, sounding worryingly like Margo from *The Good Life*.

The plumber gave a little duck for good measure as he muttered away to himself.

When the boots came off, a pristine pair of beautiful white socks were revealed, which I couldn't help commenting on.

"Nice white socks," I enthused. The plumber agreed and wiggled his toes.

Since he had another box under his arm, I offered to carry the metre-long toolbox through to the bathroom, probably because I felt slightly guilty for making him expose his white socks.

But the toolbox was going nowhere. Sad to say, I just couldn't lift it. Yet I could have sworn the wiry plumber, who was at least a foot smaller than me, had just carried it into the doorway without showing much in the way of a heart attack. I backed off laughing and asked him what on earth he had in the thing, a spare kitchen sink, perhaps?

"Probably," he replied sagely. "It's a while since I've been to the bottom of this box."

Then he lifted it as if it were a bag of shopping and strolled past me towards the bathroom.

"Through here is it, sir?" he added.

I left him to it and turned the water off.

I was no sooner back in my study and about to turn the music back on when the plumber sounded as if he might be in trouble.

"What the heck," he exclaimed.

"Steady on," he continued, apparently replying to himself.

After three weeks without hot water in the bathroom sink, the last thing I wanted was a plumber who was in two minds about the job.

"Everything OK in there?" I shouted optimistically into the bathroom.

The door was almost closed, but I could just see one of those telltale white socks.

"Fine, no problem at all," said the plumber, but just as I was walking away I could have sworn I heard someone else mutter: "Yeah, right".

"Sure?" I asked.

"Aye, everything seems to be in order," came the reply.

My study is next door to the bathroom, so I kept the music off in case there were any more unforeseen "no problem" events.

I had just sat down when the plumber was off again.

"Oh that's no good, no good at all," he tutted.

"We'll have to put that right."

"Looks fine to me," muttered what seemed to be another voice.

"I thought you'd say that," responded the plumber. "But we'll give it a go."

Either he was used to working with a mate and was filling the gap, or the toolbox had contained a tiny plumber who doubled up as a contortionist.

"Wait a minute; what the heck's going on here?" he said suddenly.

I froze and waited for what turned out to be a rather enigmatic reply.

"Not going to happen," he said.

Suddenly, the job went from doddle to crisis point and back again in about a minute.

"Well that's no good, is it."

"Keep your hair on."

"There we go. Lovely."

I heard my wife coming into the house, so I hurried to the conservatory door to meet her with the news that the plumber had arrived with the new taps and was fitting them as we spoke.

"I take it you've seen the taps and are happy with them?" asked my wife, ambushing me.

I lied and said I had seen the taps and they were perfect.

"Liar," said my wife.

"Oh you wee beauty," shouted the plumber suddenly, stopping my wife in mid-breath.

"Everyone's entitled to their opinion," he responded sharply.

"Lovin' it," he growled.

"Fair enough, whatever turns you on, turns you on, ha, ha, ha," he replied.

We stood for a moment in silence as the laughter faded away.

"How many plumbers are there?" whispered my wife. I held up one finger.

"And he's laughing at his own jokes?" continued my wife.

"Well, as long as the bill's not double as well."

"I think it's two for the price of one," I whispered back.

Several conversations with himself later, the plumber announced we now had hot running water again.

"Tricky job, was it?" I asked. "More of a two-man project?"

"Naw," answered the plumber, picking up his massive toolbox. "It's a tight space so there's only room for one person."

Then he was off. Outside, he paused for a moment before returning for his boots.

"One day I'll forget my own head," he laughed.

"Chance would be a fine thing," he replied.

The UFO

BUSTLING up the hill ahead of me, my wife stopped suddenly in her tracks and turned into a black silhouette as a pair of blazing headlights crested the next hill before vanishing into the steep trough that puts an injection of liquid lead into my legs.

This trough is particularly sly because you don't realise you're in it until you're struggling to climb out of it; then your legs get clamped suddenly between huge vices and you slow to a crawl. I had all this to look forward to and I was still only halfway up the first hill.

My wife had started up again, safe in the knowledge that the vehicle wouldn't come close for another few minutes. There was a full moon lighting the road bright enough to read a book by and a sky bristling with stars and constellations clear as road signs.

I had paused to take in a few of the more familiar ones and wondered if one of the tiny specks was a comet. I was lucky enough to see a meteor appear and streak for a couple of seconds. I called out to my wife, but she was too far ahead to make sense of my exclamations. Later, she said she thought I'd had a sudden urge to buy white goods because I had apparently shouted out that I wanted to meet her at Comet.

The moment I stopped, secretly I regretted it, because it's lethal pausing when we're out for our nightly walk. It allows my wife to take a huge lead and conversations become Pinteresque when they're bawled out across 100 yards or so and I always think that passing motorists must assume we've fallen out.

"Obviously had a tiff, these two," I see them muttering as they pass.

Either that or they think I'm a prowler and stare at me suspiciously, trying to imprint my face on their memory in case they're called as a witness to my dastardly deed, so sometimes I'll oblige them by conjuring the worst, gruesome-looking face I can manage.

Suddenly, the moon slipped behind a cloud and the road went pitch black, so I fumbled for my torch and switched it on, but it went on to flashing mode and for some reason I couldn't change it. I saw my wife turn round and shout something about epileptic fit then the vehicle we had seen earlier rose up out of the trough with its headlights full on and almost blinded me.

This is probably one of the reasons why we never encounter anyone else walking about the country lanes in the dark; you see headlights every time you blink for the next twenty-four hours.

Meanwhile, as I caught up with my wife, I was still struggling with the flashing torch.

"Give it me," she said, taking it from me and then waving it around like a magic wand and shaking it until it gave up the ghost and died. This was probably the closest thing our neighbourhood will get to Christmas lights.

The car was on us before we knew it and had stopped with the driver's head sticking out the window.

"Excuse me," began the driver looking slightly anxious. I braced myself for the usual round of questions and directions.

"Did you see those flashing lights?" he continued.

Caught off guard, I had to think for a moment.

"Sorry about that," said my wife, "it was our torch. It has a flashing mode which some twit switched on and then, for the life of him, he couldn't switch it off again.

"Look," she said, and switched the torch on to flash mode under our chins, lighting us both like a pair of intermittent ghouls.

"Oh, right, so that was you," said the bloke smiling, and we all laughed away.

'Did you think it was a UFO?" continued my wife, smiling. "My husband's always on the lookout for strange lights and UFOs, aren't you."

I opened my mouth for a split second.

"But I think they're all perfectly explainable since there's an airport about twenty miles away," she said.

She was winking at the bloke, so I tried to defend myself by saying that I had seen some strange inexplicable lights in the sky on several occasions and consequently I made a point of always keeping an eye out.

"The truth is out there," I said.

"Actually, I wasn't referring to your flashing torch," said the bloke, who had been listening patiently to us prattling away.

"I meant the groups of flashing lights that were in the sky a few minutes ago behind you."

In silence, we both turned round slowly, looking up at the sky to the east. It was like someone telling you there was a huge monster right behind you about to pounce.

"Must have been the Northern Lights," I said, but the bloke shook his head.

"Don't think so," he said, "they were sets of lights travelling south quite fast.

"When I saw you, I thought you had seen them and you were flashing me to stop.

"Anyway, they seem to be gone now, but I'd keep an eye out if I were you; they didn't look like any aircraft I've ever seen before."

Then he drove off with me shouting after him to wait and tell us more.

"How could I miss a thing like that on such a clear night?" I said.

"You were too busy playing with your flashing torch," replied my wife, "probably frightened them off."

"You can't frighten off aliens with a flashing torch," I shouted.

"Anyway, they were behind me; I don't have eyes in the back of my head."

"Could have been Santa," said my wife thoughtfully, "out on a recce looking for our house."

"Right enough," I said, "I did send him a reminder after he forgot where we lived last year."

Then we were off again with my wife at full steam ahead and me now walking with my head permanently turned backwards.

"The aliens won't like it when they land and are met by a bloke with his head screwed on back to front," shouted my wife – the alien expert.

Trouble in Store

SOMETIMES when it's snowing heavily outside and you need to buy something it's a good idea to phone the store first just to confirm if the desired item is in stock. That way, you won't have to undergo a stressful journey in treacherous Arctic conditions that may, after all, turn out to be a complete waste of time.

However, it's worth remembering that most stores don't like customers calling them. They would far rather you came into the shop and bought

stuff, even if it's the wrong stuff or things you don't need, so they'll make you call somewhere as far away from them as possible, quite often in a different continent.

You won't realise you have travelled to the other side of the planet, passing painlessly through time zones and weather fronts, because your call will be met by an automated multi-choice answering service designed like a knot garden that will ultimately make you go away feeling ever so slightly unloved, even after listening to Mozart or Cat Stevens for fifteen minutes, which is quite an achievement.

This is what large stores call customer service and sometimes, for a laugh, they record you getting lost in their system and bouncing around as if you're in some virtual pinball machine. In the end, they know you really want to visit their store in person. The phone-call business is merely foreplay.

Which is why I was so pleased with myself when I found the local branch number of the only store for several hundred miles in any direction that stocked the item my wife was desperate to get.

There was a threat of snow outside, so I thought I'd phone first and check if the item was, in fact, in stock.

"I wouldn't bother," said my wife flatly, "they had dozens last time I was in."

"So why didn't you buy it then?" I asked.

My wife looked at me as if I had my head on upside-down.

"I can't be psychic all the time, you know, it's tiring," she replied.

I thought I'd phone.

It rang until I got fed up listening to it ring, then I tried again and it rang endlessly, pointlessly, in fact. Obviously I had the wrong number so I waited half an hour before dialling again, just to be sure and probably just to annoy myself.

I then constructed a fairly detailed scenario in my mind about this store going bust and someone forgetting to unplug this one lonely telephone that now lay hidden in a filing cabinet somewhere in a deserted office.

"I think they've gone bust," I told my wife.

"Blast," she replied, "when was that?"

I told her I had no actual evidence of the store's bankruptcy, but I would get to work on it if it would help.

There was that look again.

"Or I could nip out and see if they have what you're looking for?" I said helpfully.

"You could take the car," said my wife, "it would be quicker than walking."

Since the snow had now gone beyond a threat and was now lying around waiting for more snow to arrive, I took the four-wheel drive. The store is only twelve miles away, but halfway there I entered a different micro-climate, namely one that was a lot closer to Siberia than we were. We had some snow, but it was pretty and playful and, generally speaking, rather aesthetic. Suddenly my windscreen had been painted pure white and I was enveloped in white nothingness.

Slowing to a crawl, I saw a lay-by up ahead, so I pulled in and called the store again. But still it rang out lonely and neglected. I had a strong suspicion that I was driving through a blizzard towards an empty shop – but I had gone past the point of no return.

On the other side of this sub-zero, ice-age climate zone lay the store basking in a little weak sunshine. When I parked, my 4x4 was the only vehicle in the car park covered in snow. People passing stared and pointed at it, amused.

At least the store was open and busy by the looks of things. There was no sign, however, of the item my wife needed. There was a young couple behind the counter flirting and, as much as I wanted to leave them to it, I felt compelled to ask if I could order the item in question.

"Nah . . ." was the considered response and then there was some opaque explanation about how everything just sort of kind of arrived like, if you know what I mean, like.

"As if by magic, like," I suggested.

"Pretty much, like," agreed the girl, and the boy agreed as well and turned momentarily to adjust his hair in a mirror behind him. The girl scolded him for being so vain.

"Sorry to interrupt, but could I have the shop's phone number?" I asked.

They both stared at me blankly, but then they remembered the shop had a phone. How else could they call in sick on a Monday?

Instead of writing it down, the girl announced it from memory. So I asked her to repeat it and I called it right there and then on my mobile. It rang somewhere, anywhere, in fact, but in the store.

"Oh sorry," shouted the girl suddenly, "that's my home phone number."

Then she giggled and the boy giggled back and they both giggled together and performed a little dance routine.

"Hey," said the boy, suddenly turning serious and pointing at me, "this girl doesn't give her phone number to everyone, you know."

Then the boy laughed and the girl laughed and they started pushing one another around – and I thought it was time I left. I'd had enough mating rituals for one afternoon.

On the way out, I tried the original number and waited for a moment. Sure enough, it rang somewhere far in the depths of the store, a forgotten phone that no one felt like answering. If I was a retail jargon-monger, that's what I would call "customer careless".

Fright Night

AFTER thinking I was smart taking a shortcut through an old part of town to get to the equally-old concert hall in time, I found myself mired in a narrow cobbled street, the unwitting victim of a squabble between a stubborn van and a supercilious bus – both of which were taking obvious pleasure in attempting to scrape the paint off the sides of their vehicles.

I had stopped long enough to change a CD and discover I had put in the wrong one, so I searched in the pocket in the car door for the right one and

happened to glance up as the bus took a significant lurch forward and for a moment I could have sworn it was being driven by a skeleton.

I know it's hard for bus companies to find drivers these days, but I thought there must be plenty of live people who would jump at the chance of driving around in a bus all day.

Obviously, it was a trick of the light; it was dark and gloomy, so I squeezed my eyes together in the hope that it might improve the view. When I opened them again, the skeleton was still behind the wheel – but there was worse to follow.

As the van gave up and mounted the pavement and the bus slid forward, I could see two identical young girls standing up at the front window.

Both were wearing similar pretty floral dresses and were staring directly ahead, motionless and blank faced. In fact, they looked lovely – apart from the trickle of blood flowing from the axes sticking from their heads.

They reminded me of the twin girls that haunt the Overlook Hotel in the film *The Shining* and I think that's who they were meant to be. On a bus during early evening, it was a bit distracting, particularly for old Boney the driver.

As they drew close, they must have seen me gaping at them open-mouthed, because one of them waved slightly, which made me shiver.

Then the rest of the bus shaved past revealing more ghouls, vampires and gothic frights than should be allowed on public transport.

I don't think there was one passenger that had not spent the past five hours in the make-up and special-effects department.

There were two blokes standing together holding their heads under their arms and the whole of the back seat was taken up by one huge leathery vampire bat whose wings were so large they almost obscured the rear window completely.

At some point, Halloween must have gone hardcore; this was certainly way beyond a plastic mask and a smelly hacked-out old neep lantern.

Half a dozen werewolves and a flock of blood-spattered fairies later, I stopped at a pedestrian crossing and watched a herd of sinister Santas lumber past, each one with the face of a dug-up corpse and a sackful of body parts over their shoulder.

So far, I had not seen one normally-dressed person and it occurred to me that I was suddenly the odd one out.

Just as I was about to take off from the crossing, a horrible bleached-white face with huge illuminated red fangs appeared snarling at my window.

It had stumbled off, laughing hysterically, with its similarly bloodless mates by the time I had peeled myself from the inside of the car roof.

Behind me, a 4x4 full of bandaged mummies was getting impatient, sounding its horn for me to move, so I went in search of a parking space, which was tough – the ghouls and goblins, witches and warlocks with normal Earth-based transport had already taken all the spaces.

Meanwhile, all the pavements were busy with recently-escaped raging lunatics and the poised but equally unsettling casts of countless horror films. Through the windows of bars and bistros, I could see gruesome fiends and monsters chatting up sexy lady funeral directors without the faintest flinch of discomfort or irony.

In one watering hole, there was a bloke with two heads serving behind the bar who appeared to be speaking to two different customers at once – both of whom thought they were being served by the real barman. It was like being in an off-duty living-dead horror movie.

I had time to take all this in because the back street I had sneaked into was blocked by a horde of bickering middle-aged wizards and witches, including at least three elderly Harry Potters.

There must have been about two dozen of them and at their core there was some serious curse-throwing going on that threatened to escalate into a full-scale battle of spells.

I thought if I stayed there long enough I would be able to get the best of it. Perhaps miss the first few minutes of the rather sedate concert. Then a hearse turned up behind me, driven by Frankenstein's monster, who ordered the squabblers to shift. They parted and grudgingly let us through. Round the corner, there appeared to be two policemen chatting up a posse of sexy stocking-wearing vampires who, on closer inspection, turned out to be hairy blokes. For all I knew, the policemen were also revellers in fancy dress.

"Excuse me," I shouted after winding the window down, "are you real policemen?"

"I think so, sir," shouted one of them as he approached.

"Well, there's a real fight between a load of wizards and witches about to break out round the corner," I said.

Both policemen were gone in a flash.

Finally, I found a parking space, but as I left the car dazed and amused, a squad of evil-looking blood-spattered doctors and nurses passed, shouting: "Agh, it's a human." Then they ran off screaming.

Inside the old mausoleum of a concert hall, normality beckoned with open arms.

"Ah, more humans," I thought to myself as I was met by the familiar, yet strangely comforting, aroma of TCP blended with mothballs.

Movers & Shakers

IN MY head, I have an immaculate filing system with everything in its place, and of course in the correct order. Everything shipshape and Bristol fashion, as my father used to say.

He was a man who was accustomed to life at sea, so he appreciated the value of cupboards and of crisp folded neatness, a virtue that never quite made it ashore. Yet he did his utmost to instil in me a healthy inclination towards organised tidiness.

He succeeded to the degree that I have now convinced myself that I am well organised and efficiently tidy.

I look at sloppy workers and sneer because I know they'll never be able to compete with a hyper-vigilant person like myself who has stuff foldered and filed in an easy-to-access system.

"On your computer," observed my wife, "but not in reality."

"So my computer's not real," I said. "Thank goodness for that; I can stop using it now and not feel guilty."

"You should feel guilty about drawers that won't open and feel even more guilty about the stuff that they're filled with that's being neglected or ignored or scrunched up into a massive drawer-shaped mess," replied my wife as she tugged pointlessly at one of the drawers in my study.

Apparently, this particular drawer, which was no different from any of the others in the "lack of co-operation department" contained a book she needed desperately all of a sudden.

I couldn't dispute it because I hadn't been in the drawer for about a year, certainly not since I pulled the knob off trying to get it open and had to glue it back on again. After warning my wife that she ran the risk of flying backwards into the hi-fi, she returned armed with a long metal ruler, possibly to measure the extent of the drawer's stubbornness.

"So when did you last see this book?" I asked.

"I don't have dates; do you specifically need dates that you can input into your MENTAL filing system?" she said, giving the drawer what looked like a painful poke with the ruler.

"In broad terms," I said, "what are we looking at, a year, six months, six days?"

"Two months max," replied my wife, shaking her head. "What is this, anyway, is there some kind of time limit on stuff in your drawers; does it all expire at a certain date and automatically get moved to the nearest landfill?"

My wife got a letter last week informing her that she was going to be included in the next edition of *Who's Who in Scotland* and this has done something to her capacity for dispensing cheek to the degree that hardly an hour has passed that I haven't declared that she should be listed in *Who's Cheeky in Scotland*. She would, of course, appear on every page, complete with various photographs of her cute but increasingly cheeky face.

"If it's two months, you're out of luck because the contents of that drawer and its pals haven't seen daylight for at least a year," I announced smugly enough to warrant a smack.

Suddenly, my wife had that mutineer look on her face, the one that always

makes me feel like Captain Bligh. I also couldn't help noticing she was now brandishing the long metal ruler like a professional.

"So where's this year's junk?" she demanded coldly.

"Around . . ." I said hesitantly while making an appropriately vague gesture.

"Around," she exclaimed. "You know what we need, don't you?" she snarled into my ear before marching off.

"A bigger house," I said quietly finishing her sentence.

"No, a bigger house," she shouted from the kitchen.

Strangely enough, we've been engaged in the "bigger house" debate ever since we moved from a big house to the smaller house we now occupy. An exercise my father would have likened to moving from an aircraft carrier to a submarine.

I've been told it takes a special state of mind to be a submariner and after living in our cottage for seven years I think I've acquired it. Consequently, every inch of available space has been filled, mostly with junk.

Now when we visit large houses I, for one, get freaked out by the potential for the space to swallow me up. My wife, on the other hand, just gets freaked out by the potential. Rooms with high ceilings in particular have a curiously mesmeric effect on her; if they have tall sash windows then she has to be brought round with a brandy.

If we did move to a larger house, I reckon we would have to be careful what it looked like because there is a chance my wife could spend a lot of time in a trance-like ecstatic state. Although I have been known to admit that having more space would be handy and I'm actually all in favour of living in a bigger house, I can't be bothered moving to one.

For a start, I'd have to empty all those drawers, cupboards and cabinets that have been lovingly stuffed to bursting point. Alternatively, we could just sell the entire contents of our house and buy new stuff.

Then I had a brainwave that rather ingeniously involved taping up the drawers and cabinets and moving them with everything inside them. It was brilliant and seemed like a plan worth testing, so I found some heavy-duty sticky tape and got to work on a chest of drawers then tried to lift one end.

It was heavy and I had to rock it from side to side to move it, but it was

nothing a bunch of removal men and possibly a small crane couldn't manage. To my amazement, once I had removed the tape, one of the drawers opened enough for me to see that it really was full of junk. Four ruthless refuse bags later and I had three practically empty drawers.

"I think I've solved the bigger house problem," I announced to my wife.

She looked delighted when I showed off the empty drawers.

"Excellent," she enthused, "which one do I move into?"

A Change in Circumstances

I AM never quite convinced that the tiny, fragile old lady I meet in the care home is Isabelle, my mother-in-law, until she takes my hand and stares at me from across perhaps a decade. Silent things then fly between us like radio waves packed with secret information. When Isabelle speaks it's like a coded, half-remembered foreign language.

She has almost said my name a couple of times but it could just be wishful thinking. Recognition seems unlikely since Isabelle doesn't really know who I am; in fact she probably doesn't know who she is either.

So we face one another, holding hands, finding comfort and a sort of healing energy from the fragments of one another. Isabelle's grip is tightening as she grows ever more translucent and shrinks back into herself.

We now have to prize her thumbs gently away so that someone else can have their hand locked into her vice-like grip. The trouble is all her visitors want to get as close as possible to her and to make some form of contact with her, to find her again.

In a way the same thing happened to my mother, she unpeeled like a set of Russian dolls down to a miniature version of her former

self, so small when she was sitting in her armchair she looked as if she was visiting a giant's house.

My mother may not have had all her buttons on, but she knew where they were. My mother-in-law, on the other hand, has lost hers to the spell of Alzheimer's, a disease that ten years ago when Isabelle first began manifesting symptoms, few people had barely heard of.

Now there is hardly a family in the country that isn't affected in some way by the disease. It's almost like a form of mass amnesia, although it's not just about memory, when you have Alzheimer's you go missing, so subtly that at first you don't even notice it yourself.

Ten years ago, when Isabelle forgot that Princess Diana had died and turned on the television and was completely baffled by the spectacle of her funeral, it didn't go unnoticed. But then she was after all in her mid-seventies.

Still a clever woman, and an avid reader, she could recount in extraordinary detail events that happened to her fifty years earlier, so why would anyone bother to question what was going on. She did however, become very good at picking up the wrong end of the stick. Information was going in, but under pressure it wasn't being sorted out properly. Most of the time we all laughed and it became one of her familiar, cosy character traits, so much so that I even wrote a column about it and she laughed about it herself.

Little did we know that when she said things like, "I thought I'd read this book before, but obviously I haven't" it wasn't as we all thought just a little absent-mindedness – the effects of old age.

To my wife however, the Diana incident was significant, it marked a sea change in her mother that proved to be momentous and one that her father would deny for as long as he possibly could.

We saw only a fragment of it. So when Isabelle asked how my parents were doing a few years after they had both died, my father-in-law shook his head slowly with the weariness that comes from repeatedly correcting someone. I was slightly taken aback and so was my wife, but you always look for the positive and hope it's just something temporary.

Eventually Isabelle would have to be constantly reminded that her own parents wouldn't be coming to collect her because they had passed away quite some time ago and she would stare at us in amazed disbelief.

It was the matter-of-fact way she would ask you things like, for instance, who the man was in the other room referring of course to her husband after pulling you into the kitchen.

"You'll have to ask him to go, he can't stay here you know." She would say, then add: "If my husband comes home and catches him here I don't know what will happen."

Sometimes we had to re-orientate her by taking her out of the house and up the street a few yards and then back again. When it didn't work and she said something like, "Oh, this is a nice house, who lives here" we would take her out in the car, quite often at midnight because she was so agitated she would have phoned the police and had us all arrested for kidnapping her.

There were times when we began to question our own sanity and our own versions of reality.

She would sit up suddenly and ask where all the children had gone or tell you to your face that you were someone else, a relative or a friend and sometimes it was easier just to be that person than correct her, which my father-in-law did until he ran out of steam himself and turned into a full-time carer.

Ironically, of course, Isabelle used to joke about the possibility of going senile and would make us promise to shoot her.

It's the sheer contrast that gets me. She had been a very clever woman. A voracious reader, she would recite chunks of the classics or poetry and she was a talented landscape painter.

As a nurse and midwife she had run hospital wards and her medical knowledge was literally encyclopaedic.

Then one day it occurred to me that I hadn't seen any new paintings for a while.

Bad eyesight was blamed or a new pair of spectacles were needed. The same applied when I thought I hadn't seen her reading for some time and the piles of books that had always lain around had gone.

Apparently in India they don't make such a big deal about this sort of thing, there isn't the same emphasis placed on memory, but here we don't seem to be much at all without it.

We are always the sum total of who other people think we are and this is what my father-in-law couldn't come to terms with.

In a sense because his wife didn't know who he was, or cared if he was alive he felt he had been erased. Alzheimer's, it turns out, isn't an event that befalls an individual, it happens to their family and anyone who knew them.

I had to read some of Isabelle's mail this week. One letter was from the pension service advising her of her revised pension, due to the fact that her husband had passed away just before Christmas.

After detailing the amounts they thought they had better explain why this had happened. "This is because of a change in your circumstances," it said.

Understatement doesn't really cover it, but I probably couldn't have put it better myself.

Shopped

THE message list was a small, neatly-folded, recycled white envelope and I barely gave it a second thought before shoving it into my pocket.

Really, I should have known better and looked at the note. A few days earlier, I had gone down to the local shop with a message list that when opened turned out be a folded-up white frilly paper doily.

"Ooh, that's nice," smiled the woman behind the counter, "did you make that one yourself?"

I said I had and since she mentioned it I was rather proud of it because it was the first one I had made at doily evening class.

Apparently, it was the only piece of paper my wife could find in her

generously-equipped art studio – presumably all the other pieces of drawing-paper must have been hiding.

So it was either the doily or a large, freshly-prepared canvas, which would have been awkward and embarrassing to carry around while shopping.

So she just settled for embarrassing.

At least the latest message list was slightly manly. It also had very little on it apart from a brief and rather mysterious one-line instruction.

Unfortunately, I didn't discover this until I was in the supermarket behind a large trolley into which I had already dumped a newspaper and several magazines.

Now then, I thought to myself, what torture have we got in store today?

"Check the boot," said the note. I turned it over, but that's all there was, just "check the boot".

Check the boot for what, I thought. For some reason, it crossed my mind that perhaps my wife had stowed away in the boot for a laugh. But she was too busy for time-wasting frivolity, which is why I had been volunteered to go to the supermarket.

Leaving my trolley beside the magazine section, I went back to the car to investigate the boot and found a big, environmentally-friendly shopping bag, half-a-dozen cardboard wine-carriers and a large sheet of thick grey cardboard, which had obviously once served as the backing for an A3 sketch pad.

This chunk of cardboard was covered in writing and doodles and at first glance it could have passed for a section of the Da Vinci code.

But then the reality sank in: I had been sent to the supermarket with a Big Brother shopping list.

It was so thick I would have needed a saw to cut it, so folding it was impossible. I stuck it into the shopping bag and marched back inside to my trolley, which of course had been taken, presumably complete with my choice of newspaper and magazines.

They weren't on the list, anyway, so I got down to the business in hand. It took me some time to work out why the items were grouped inside clouds, although wine and water were inside a happy sun. It turned out the items were all grouped together by aisle, some were even colour-coded or had little thumbnail sketches.

I couldn't bring myself to walk around with the Dumbo-sized list in the trolley, so I had to keep pulling it out of the shopping bag for a sneaky look. Unfortunately, there was an item that had been scored out and then rewritten and scored out again, but I thought I'd better get it, anyway. However, no matter how I looked at it I just couldn't make it out.

Desperate and wilting by the second, I stopped a passing assistant. "Excuse me, I wonder if you could help me," I said.

"Certainly, sir," said the assistant, smiling broadly, so I presented her with the message list and pointed at the scored-out, written-over item.

"Could you tell me what that says?" I asked.

She looked at the big sheet of scribbled-over cardboard and started laughing to herself. Then she glanced round, but there was only a very old lady at the end of the aisle, immobilised apparently by a fascinating tin of peaches.

"Is this a wind-up?" asked the assistant as she looked at the huge message list, then added, "are you a pal o' Danny's?"

I told her my wife had written the message list and that I doubted if she intended it to be amusing. However, even although it was all in large print, I still couldn't understand some of it and, frankly, I'd had enough and from now on we were shopping online.

The assistant looked me up and down and raised her eyebrows.

"It's different, I hiv tae admit, but ye can tell Danny he'll hae ti try a lot harder if he wints tae catch me oot," and off she went. Then my phone rang and thinking it was my wife checking up on me I answered it in a very silly German accent. It was a client. Keeping up the daft accent I said I would put myself on, but it was slightly awkward since we were just about to go through airport security.

Then an announcement rang through the supermarket.

"Multi-skillers to checkouts, please, multi-skillers to checkouts."

I said our flight was being called and that we would have to go.

"To the checkout?" asked my client.

"Ja," I declared. "Ve have just landed."

Technically, it was a holiday Monday so I suppose I could have been away on a long weekend with my German ski-instructor boyfriend, Horst.

An hour later, I reached the end of the list, which was about half an hour after I had reached the end of my tether, so when I read "Extra-thick tinfoil – about ten aisles back – oops, sorry," I barely flinched.

I turned round and like a pre-programmed android I went dutifully in search of extra-thick tinfoil. There wasn't any, so I just bought the ordinary thick stuff.

Apparently, this was the only thing I bungled on the entire list of fifty-four items and because of that my wife has advocated using the giant-cardboard technique on a regular basis. Which is fine by me because it gives me something big, but not too life-threatening, to hit her with.

But 'n' Ben

MY WIFE doesn't need maps. She navigates by emotional intelligence. Basically, the further we get from our desired destination the more emotional she gets. It's a bit like a GPS system in reverse and a lot more exciting.

We were looking for the entrance to a windfarm, for no other reason than sheer nosiness and since I was navigating we were going nowhere very slowly. We had passed the windfarm in the distance twice and just wanted a closer look, but it seemed to be playing a game of hide and seek with us.

One minute we could see the white blade of a turbine slicing the sky a few hundred yards away and the next it had completely vanished.

"You would almost think they were moving," I said. My wife thought about this for a moment and decided it wasn't worthy of a reply, instead she told me to take the next opening on the left, which of course I didn't. I hadn't run out of dead ends yet.

I once walked around inside the tower of a wind turbine when it was

lying on the ground. I actually thought it was a tunnel connecting two buildings, which gives you some idea of the extent of my knowledge about wind turbines.

In my defence it was the first and last time I've been inside a wind turbine, but for some reason, perhaps like an updated Don Quixote I'm drawn to these windmilling giants. From a distance they're elegant balletic mime seems suspiciously perfect and quiet. It's a beautiful dance that has nowhere to go and it throws the rest of the world around it out of perspective and reality.

We were bashing all this sort of stuff about while we drove round in an ever-widening circle until eventually I gave up and took my wife's advice.

"It's down here!" she declared with impressive certainty. No "might be" or "could be", just down a road she had never seen in her life that, as far as I could make out, was going in absolutely the wrong direction.

So down this pretty little road we swooped and three or four very attractive rural miles later the wind turbines began to appear one by one as if they were being called in for supper. Then they vanished.

"Just keep going," instructed my wife so I did, hoping of course that she would be proved wrong before we ran out of petrol.

Suddenly there was a sign, a notice board and a crude carpark. Up a long track through fields we could see the tops of the wind turbines.

I pulled in and sat there staring at the windfarm in the distance trying to work out how my wife had got us to a place she had never been without the aid of a map or the secret assistance of a helicopter.

I was impressed but at the same time slightly flattened.

"So how does that work?" I asked, "Intuition, inspiration?"

I didn't expect my wife to give away her secrets and she didn't. "I thought it was fairly obvious," she replied matter of factly. "So what's happening now?"

My wife often asks this question and I always think the answer is fairly obvious but I say it anyway.

"I thought we were going for a nosy round the windfarm," I replied turning off the engine.

"Not in these shoes," said my wife.

Actually I was slightly relieved to hear that. It was starting to rain and

there was quite a raw wind getting up, nothing that would have stopped my wife in normal circumstances.

"Oh well, we can come back some other time," I sighed, laying the disappointment on thick and set off.

"Turn left!" shouted my wife suddenly, as I pulled out of the little carpark. So I did out of fear more than anything because she gave me such a fright I thought I was going to hit something in the road I hadn't spotted.

Now we really were driving in absolutely the wrong direction, certainly as far as I was concerned.

"I think you'll find we should have turned right," I muttered, more to myself than anything.

"Probably," answered my wife completely distracted. "Just keep going down here," She added peering ahead in front of us.

Then we turned a bend and there it was, quite possibly the cutest little country cottage we have ever seen, certainly since the last cutest little country cottage we saw. I had to admit from a distance through a veil of gentle rain this one was pretty high up on the cute/quaint register.

Like most cute cottages it had a cute face with little old windows for eyes and a big old wooden door for a mouth. It was white and had a red roof. There was obviously no question that we wouldn't stop and explore it, except for the problem of my wife's unsuitable footwear.

"You don't understand," said my wife. "My shoes are only unsuitable for trudging round windfarms!"

It was good to hear that because this cottage didn't have a path, it just had nettles and other unfriendly plants thick as you like all around it. There was also a For Sale sign next to the gate, which elicited a long wistful sigh of delight from my wife, and made me feel queasy.

The red roof of the cottage turned out to be corrugated iron and the big old door was wide open but then there was nothing inside that anyone would be interested in because there was nothing inside, not even a real floor.

There were four walls though, some of which had been plastered and still had the archaic remains of faded wallpaper sticking to it. There seemed to be a hallway in the middle of the cottage that neither led anywhere nor

did anything much at all really. There was a fireplace on one side and on a windowsill a Parcelforce failed delivery notice.

I couldn't find a toilet or any evidence of running water or electricity but my wife was taking down the solicitor's phone number from the For Sale sign.

I stood there looking back at the road we had just come down and realised my wife could obviously see this cottage from the main road. I hadn't been taken to a windfarm; I had been led up the garden path, literally.

"Let's buy it!" I shouted, "It's magic!"

My wife jumped up and down in a bed of nettles.

"Honestly!" she shouted back.

"Absolutely!" I replied.

We photographed the entire place and were warmly ecstatic all the way home, rebuilding the cottage, converting it, whatever.

Lucky for me it turned out to be almost twice the price we paid for our own cottage just over three years ago.

"Outrageous!" declared my wife, demonstrating once again the sheer depth of her emotional intelligence.

Sooty

FROM a distance against the twilight sky it looked as if someone had baked an enormous loaf in the village – perhaps to gain entry to the *Guinness Book of Records* – and it had risen crazily out of control and risen above the roof-line of the houses. Only the church tower and a few tall trees poked darkly through the creepy giant loaf.

I had a vision of a band of sweating villagers battling to tie the Gulliver loaf down before it swamped the outlying farms and turned them into a living picnic.

"Looks more like an obese Victoria sponge to me," mused my wife as we walked up the hill towards the village.

"Although I have to say it doesn't look very tasty."

The trees on either side of the road form a tunnel entrance to the village and that tunnel mouth was now stuffed with the strange glowing loaf. Lit from within by the street lamps, this massive lump looked as if it was growing before our very eyes.

Fortunately, there didn't seem to be much danger of it spreading down the road and consuming our cottage as it stopped dead at the threshold to the village.

We speculated that it might be some kind of portal through to another world, although a couple of cars had emerged with their headlights blazing, so it could just have been localised fog, a dense haar that had risen like a spectre from the freshly-harvested fields.

"A haar that can't be bothered rolling down the hill towards our cottage?" asked my wife.

"A lazy old fog?"

Strangely enough, although I had just arrived home from the opposite direction, my wife had walked through the village ten minutes earlier and there had been no mysteries whatsoever to report.

"No giant loafs on the prowl?" I asked as we drew worryingly closer to the village edge.

"No giants of any description," confirmed my wife, who now seemed be to inhaling the scene in case it suddenly vanished.

"Aren't the elements wonderful?" she enthused. "Isn't it great how something wild and natural can overwhelm you without warning?"

I was about to agree when she caught hold of me by the arm.

"Actually, do you think we should turn back?" she asked nervously. "It looks a bit too elemental to me."

"In the interests of science, I think we should carry on," I replied. "Anyway, it might be smoke; maybe there's a fire."

Like her mother, my wife is a natural one-woman emergency service so, as I suspected, the words "smoke" and "fire" galvanised her into action.

Within moments, she had pulled on her superhuman suit that makes her completely invincible and she was off bowling up the hill ahead of me like a petite but determined armoured car, while I followed swiftly behind fumbling with the torch.

A dark figure emerged from the entrance to the big house that sits on the village edge, but it disappeared as quickly as it had appeared, so we ploughed on and just a few yards past the entrance started coughing.

By the time we reached the village green thirty seconds later, we had decided it was smoke and that something was on fire, yet there was no sign of it or for that matter no sign of anyone else in a state of high panic and alarm.

The school, church, restaurant or any of the village buildings could have been blazing away, but no one seemed in the slightest bit interested. Then a suitably-distressed woman loomed out of the smoke, coughing and shaking her head and flapping her hands as if she was trying to fly her way out of the acrid smoke.

"Well, it's nae the school or the church or the restaurant," she informed us. "But something's on fire."

It was then we decided there was a strong smell of soot.

"Must be someone's chimney," I said, to which the woman looked round and said: "Well, it's nae mine, I can tell ye that much."

This narrowed it down to a couple of hundred. She then wandered off wonderfully distracted by the whole event in search of evidence, which was a pity because she missed the arrival of the first fire engine. It came hurtling out of the fog, blue lights flashing and its klaxon screaming like a dying banshee.

The fire engine screeched to a halt right before us with the driver hanging half out of his window.

"Rowan Cottage," he shouted keeping formalities and dialogue to an appropriate emergency-mode minimum.

My wife and I stared at one another in a state of bemusement mixed with mild terror, then we looked back in silence at the driver who I imagine was now cursing his luck for stopping and asking directions from the village idiots.

"But that's our house," I said, "and we've just left it and it wasn't on fire, I don't think."

My wife was looking back down the road to check and it did occur to me that in my enthusiasm to see the giant loaf in close-up I hadn't actually gone into the house when I had arrived home.

Perhaps my wife had torched the place and dragged me off on a walk to distract me, but this was no time to ask her.

The driver, meanwhile, was busy consulting his instructions.

"Sorry, Rowan House," he shouted.

"Big house just there," I replied, pointing at the house, then added for good measure, "with smoke billowing out of it."

The fire engine tore off down the fifty yards to the house entrance and squeezed itself into the drive.

We reckoned it must have been the owner of the house we had seen earlier, obviously waiting for the fire brigade to arrive and quell the angry combustion in one of his chimneys.

After so much excitement, we only walked for a further quarter of an hour. From our garden, the fire engine's twinkling lights looked like a magical fairground ride shrouded in mist. Meanwhile, TV and computer screens blazed in the houses, private worlds remote as far-flung stars.

Panto Hell

JAMMED like a human barricade between a pack of howling cubs and a gang of shrieking beavers, I realised suddenly what Edvard Munch's painting "The Scream" was really about.

That poor distressed figure holding its fragile face, drained of colour and life is escaping from a panto.

Actually, I think it's covering its ears. I certainly was. I've tried earplugs, but you tend to miss important parts of the plot, such as who lives happily ever after.

We were still an hour and a half from a cross-dressed wedding and already the paper flags had started flapping like a great flock of frightened birds – startled, no doubt, by that primal scream.

This is what they arm the audience with at some pantos, as if they're not dangerous enough.

I had been whacked on the side of the face twice and had decided that small children should carry a warning saying: "This could put your eye out".

Some of the more creative cubs had discovered the flags were more effective when used the other way round and had embarked on an attack-and-feign-innocence campaign.

Mainly, this involved stabbing the bottoms of the kids sitting in the row in front.

Every time one of the unsuspecting victims leapt up with a yelp, they got into trouble for screaming out of turn, so they couldn't win.

It was very effective.

The naughty sniggering cubs were on the brink of getting their victims choreographed into a tiny human wave of pain when the panto set exploded.

Oh how they cheered. Convinced that the show obviously was over because the castle had unexpectedly blown up unexpectedly, some of the kids stood up and decided it was time to go home and eat different stuff.

A chunky teenager in a hard hat turned up on stage wading easily through the polystyrene rubble to convince them otherwise.

But he had a hard job on his hands. He kept waving at the kids with mounting enthusiasm, but they just gazed at him, deeply puzzled, and then turned back to their sweets.

"Look who it is, kids," shouted an ecstatic village person of indeterminate gender. "It's Bob the Builder; he can put our castle back together again, can't he, everyone?"

I think the kids were meant to shout back in triumphant unison: "Yes he can," but there were some mixed feelings as to the true extent of Bob's abilities.

Instead, they started chanting: "We want Santa; we want Santa."

I'm no expert, but the collapsed castle definitely looked like more than a one-man job to me. Bob seemed very confident, though, and, just in case we were in danger of losing the plot, another ecstatic village person insisted that Bob had come highly recommended and that he would do a very fine job rebuilding the ruin and then they could all get on with their fabulous fun-packed adventure.

"No he won't," shouted a munching cub behind me. "Cos he's a cartoon character," explained his pal.

The adults in the audience shivered with laughter and the floor was dancing suddenly with escaped Smarties, ready to be crushed underfoot.

When I looked up, there was a small, modern-shaped boy onstage, standing with his fists firmly on his hips and giving the villain of the piece the evil eye.

The boy had obviously come to the end of his tether and just had to do something about that bad man who was terrorising the villagers.

However, as he sized the villain up for a swift kick to the shin, the boy was swept up suddenly and carried off by an apologetic woman who was trying to keep a straight face.

The boy, meanwhile, continued pointing at the villain who, for good measure, took several wary steps back from the footlights.

"Too much WWF Wrestling, I think," said an adult voice nearby.

Meanwhile, another tiny boy had to be bustled out gingerly because the bangs and flashes had scared him witless – obviously another Munch life model in the making.

I was more concerned about the Dame, a big hairy-armed bruiser with a tattoo and a shock of vibrant blue hair, who kept winking lasciviously in my direction. For the moment, some poor bloke who was wishing he hadn't bought a front-row seat was getting all the unwelcome attention. But it was only a matter of time; the Dame was looking for fresh blood and I had decided it wasn't going to be mine.

I had 400 small but very fired-up children around me and I wasn't afraid to get them even more fired up.

Quite frankly, me and pantos haven't been the same since I spent an hour chatting to Matthew Kelly in his dressing-room while he transformed himself into Mother Goose. It was the first and only time I have tightened a man into his corsets.

Fortunately, most pantos have a tendency to come unstitched, allowing a glimmer of reality to shine through momentarily.

Some of this, of course, is well rehearsed and you can see the same blunders in every performance. The inebriated evil wizard who couldn't be bothered being evil wasn't, or the female technician who flashed her chest in the wings at the lead man and threw him into a blank panic. Neither was the rear end of the panto horse that fainted and was dragged around like a dead weight for the rest of the scene while the audience fell about laughing.

Meanwhile, across town at the big posh panto at HM Theatre, a plot had been hatched that seemed to sink the whole panto before it was even launched.

I thought I was about to get a night off when one of the usherettes, Joyce Falconer, walked hesitantly onstage before curtain-up to tell everyone that the performance of Cinderella had been cancelled. Apparently, the Fairy Godmother had injured herself, or was ill, but we would all get a refund – except me, of course.

The audience took it to heart and began booing. Some people stood up grumbling, but then events took a strange turn for the better as Joyce received the *Stars in Your Eyes* treatment and turned in a flash into the Fairy Godmother.

I was impressed. Even more so when Joyce's wand stuck in the curtain and was pulled permanently upward and out of her grasp. For one chilling moment, she held on to it, thinking it would pull free. She was on her tiptoes before she let go and it was a real nail-biter to watch.

Stumbling bewildered from the theatre into the crisp starry night, having been well and truly pantoed for the umpteenth time in so many weeks, I was stopped by the sound of loud "ho, ho, hoing".

From around the corner came a coach packed full of big, jolly Santas.

Typical, I thought, you wait all year for one and then sixty of them arrive at once.

As they drove off into the distance, half-a-dozen of them waved at me from the back window. I just stood there wondering which was going to visit me. I think I'd earned it.

Hampered

THERE had been so much hamper talk going on I was getting queasy spells punctuated by phantom attacks of indigestion and heartburn. Then I would get cravings for mince pies, preferably accompanied by a glass of mulled wine.

There is only so much hampering a man can take while ordering online.

"If I'd known there were so many different types I would have started this a lot sooner," drooled my wife as she stared wide-eyed and salivating at the screen.

"Wow, look at that one; it's massive," she declared. "Now that's what I call a hamper; how much is that one?"

It was over 100 quid, so we moved rapidly on, reminding ourselves that the recipient of the hamper was a worthy individual and not a small country. So we trawled through a few dozen more, half of which were already sold out, which made us panic slightly.

"I want the sort the Famous Five took on a picnic," announced my wife, frowning at the computer screen.

"Might be a bit mouldy by now," I replied.

"There's one," she shouted excitedly, "look at that, it's heaving with stuff."

I had to admit it was heaving all right and if I ate half of it I'd been heaving as well. There were boxes, jars, packets and bottles of festive gourmet treats spilling out of a big basket on to a tartan rug. It was positively bacchanalian and at just over fifty quid a touch more than we were planning to pay, but it looked the business.

We had decided early on in our quest that we had to find the hamper we would be delighted to receive, nothing less would be acceptable, so to make sure we were making the right decision we considered at least another couple of dozen options before we returned to the hamper of all hampers and stared at it longingly again.

"I wonder how much it would cost if you wanted to send it airmail?" I mused.

"I don't think they'd allow it on a plane," said my wife, deep in a fantasy feast.

"That's a week's shopping to some folk," I reflected.

"Ten years ago," replied my wife.

Still, it looked like a week's luxury shopping to me, so we bought it. Just as I was about to type in the recipient's address, my wife had second thoughts and decided she would deliver it in person, just in case it went missing in the post.

Actually, I think she just fancied a whiff of those delicious contents. There would have been a day in our house when half of that hamper would have been scoffed at one go, but not now in these leaner times when all we get is a sniff of someone else's chocolate-bar wrapper.

We waited with mounting anticipation for the hamper's arrival and wondered if it would fit in my wife's Jeep. There was no way it would fit in my car and we laughed at the prospect of having to hire a van to deliver it.

I also started growing envious of the recipient of the hamper and hoped they would appreciate it as much as I would. The hamper itself looked like a handy thing, the sort of basket you would instal in the loft for the storage of fancy-dress outfits.

Just a few days later, on our way out, a delivery van passed us about 100 yards from the house and my wife, sniffing impending hamper, shouted for me to stop. So I about turned and drove back to the house to find the van idling outside our gate.

"I'll give the driver a hand," shouted my wife as she dived from the car.

She hopped around excitedly as the driver unlocked the back of the van and jumped inside. She gave me the thumbs up and I started rubbing my hands with glee.

My wife told me later that when she offered to give the van driver a hand he looked at her as if she was off her head, then she found out why when he leapt from the van with what appeared to be a shoe-box under his arm. She shook her head at me, picked up the box and jumped back into the car.

"It's something for you," she said flatly. "Some fascinating bit for your computer, I think."

This was news to me, since I had forgotten to buy any fascinating computer bits lately. So my wife reached over and picked up the box and shook it then decided to unwrap it.

I consider myself very lucky not to have heard a woman wail with such deep heartfelt disappointment before and frankly I never want to hear that pitiful sound again. Fortunately, it didn't last long, because my wife turned very nasty and tried to strangle the little box, forcing the straw out of it until I stopped the car and wrestled it from her before she could throw it out the door.

"It's full of doll-house food," she screamed.

"Maybe it all inflates to a real size when you take it out," I said, raking through the straw and discovering here and there tiny jars and even tinier boxes.

"You could post it through a letterbox, it's so small," shouted my wife.

Then we had a brainwave. The hamper company had sent us the wrong hamper and it was a silly clerical error that would be easily rectified.

We checked it later online and it was all there, except that it was hard to see how all the stuff we were looking at could be squeezed into such a small hamper. Needless to say, we hadn't paid attention to the actual size of anything.

When my wife told a friend, she looked horrified. It turned out she had been sending a relative that very hamper for years and had always wondered why there was never a word of thanks.

Much augmented to the tune of another thirty quid, the hamperette was delivered with the same spirit of the season with which it was always intended, just slightly faster.

Selling Up

FOR some reason my wife's parents rarely settled in the same house for very long. Perhaps a certain shared wanderlust drove them the length and breadth of the country. Either that or they were part of an unsuccessful witness protection programme.

To some degree my wife has inherited her parents' itchy feet so in thirty years we've moved house so many times I have now lost count but within a thirty-mile radius it would be possible for us to drive past at least six previous houses.

This is small fry compared to the number my wife's parents clocked up.

Last summer, more by accident than design, we revisited the series of houses in which my wife spent her formative years, or at least most of them. I emphasis the word "series" because I thought we were going to see two houses at the most, but within a few miles I had already seen a handful and I was beginning to wonder why my wife's parents didn't just buy a caravan and take to the open road.

As we drove from one similar-looking crescent to the next I quickly lost my bearings. My wife held on to hers a little bit longer but eventually she gave up and confessed that the disruption of familiar landmarks was playing tricks on her memory.

Consequently, we drove round several villages several times until they all blended into one quaintly-charming village with a backdrop of rugged hills frowning down on it.

"There was a burn there that ran behind the house," my wife said, "or is it over there?" she added, "no it's the next village, sorry."

That was the house that was haunted by a small boy who stood in a state of some distress at the foot of her mother's bed in the middle of the night. He had drowned in the burn that ran past the bottom of the garden.

Some of the houses my wife had lived in were very close to one another, even across the road, round the corner or at best up the hill. Then there would be a giant leap to a house in the next hamlet along the glen, followed by a sideways trot to a bigger house across a field.

It was like a life-size game of monopoly vividly enhanced by my wife's anecdotes about each house.

"That's the shop that was owned by the really scary woman," she said pointing to a tiny, pleasant looking corner shop, "up that road . . ."

But we never found out what happened up that road.

Over the years I've absorbed so many stories about my wife's childhood houses they have become suffused and confused with my own. I've dreamt about them and famously seen one on TV.

In Harrogate, the TV crime drama *Frost* was filmed in the house my wife spent her middle teen years. It was fascinating to see inside one of the houses my wife had grown up in and had described so memorably now occupied by a fictional suspected murderer.

"The wallpaper's different," said my wife, glued to the TV, "but the living-room carpet is the same."

It's always good to get some detail into the story.

I only knew four of my wife's parents' houses personally, but each one is still inhabited in my head with a separate archive of memories and events. None more so than the last one, which stands almost empty with a For Sale sign outside it that catches me by surprise every time I see it like a slap in the face.

"Who the heck put that there," I hear myself shout in my head as I stop the car at the end of the driveway.

The inevitability of it doesn't soften the blow or the lasting sinking feeling that follows me up the path and into the silent house. Sometimes that sense of bleak, empty puzzlement sneaks up on me during the day and it has to be shaken off. In the house, in this last home that was the distillation of all the houses that went before it, that feeling reaches a crescendo from which there is no escape.

My father-in-law would have no doubt laughed at such sentimental nonsense. He bought and sold houses like they were cakes. He must have been an expert at moving furniture and emptying cupboards and packing stuff in boxes, he did it for sixty years and every time he moved he took a little of the house with him.

Sometimes it was a tool he had fallen heir to from the previous owner or a packet of seeds he carried from one house to the next without ever planting because he never quite found the right spot in the new garden he was hoping for.

Somehow it fell on me to sell this last house on behalf of my wife's mother who left it for a nursing home four years ago in the belief that she was living with a strange man, possibly a housebreaker or a squatter who had taken over the house and convinced everyone he was her husband.

My father-in-law never got over that one, it bothered him to the end.

Even with the house stripped back to the barest furnishings it still must seem happy and welcoming to viewers. For me it chimes of the usual family sounds.

My parents-in-law lived in this house for fifteen years, the longest they had lived in any house and in those years, in that front room and kitchen and in the lovely garden our sons grew from mischievous capering boys into men who could hold their own in a political or moral debate with their grandfather but still dance with their grandmother when she burst suddenly into an old song.

My question as I go through the silent house and sit in the same easy chair in the silent living room is, how it comes to this?

I'm like the last man in a relay race that everyone else gave up on. Then I leave. One day I won't have to go back.

The For Sale sign catches me by surprise every time I see it like a slap in the face.

Wagons Ho!

Although it was lashing biblical rain I was enjoying myself on the porch with my new friend. It was strangely comforting being so close to the wild, wet weather while remaining perfectly dry.

The slightest change in wind direction of course and we would have been soaked to the skin and my wife, who had the braved the elements to investigate the garden, would have fallen flat and then rolled down the steep grassy hill to the bottom of the garden cocooned inside the huge red golf umbrella I had given her.

It was undoubtedly the wind that was keeping her vaguely upright, that and the umbrella. Again, the merest turn to leeward and she would have been off across the gloomy wet rooftops like Mary Poppins.

My wife's likely landing place was in fact the topic of conversation on the porch. We had exhausted everything else. There was no point in discussing the house, it spoke for itself, although to be fair it sort of rambled on in a language I couldn't completely understand.

My new friend the estate agent had summoned twenty-odd years of industry vocabulary to fill in the gaps. My particular favourite was his colourful description of the greasy, gloss-painted kitchen as having an improvised, freefall atmosphere. "Like jazz," he purred, "it's the spaces in between the notes that are the most important, the most poignant."

For a moment I stroked my imaginary goatee beard and thought about the word "poignant" being used to describe kitchen appliances that were built before rationing.

"Might be better to get rid of the whole thing then," countered my wife, "and just have one large jazz kind of space."

The estate agent was impressed with this.

"She's good," he said looking at me and smiling, "so good in fact I'd give her a job."

"Before you sign her up," I whispered, "you might want to know that she just wants to move house because she can't be bothered defrosting the fridge."

"So what's the story in here?" shouted my wife from an adjoining room. "This must be where Richard Attenborough made that film about the famous murderer."

"10 Rillington Place," I said to the estate agent, keeping him in the loop.

He made an upside down smile and shook his head. "Not one of mine," he declared.

"What's that smell?" asked my wife, looking very perturbed.

"Victims?" I mused.

"Lovely view!" piped the estate agent, standing on his toes and straining to catch a glimpse of a greenhouse that might have looked vaguely interesting before it was bombed.

"So let me get this straight," began my wife with a distinct edge in her voice, "there are two toilets downstairs, one with a bath."

"Correct," snapped the estate agent.

"The previous owners must have had very small bladders," said my wife with a sympathetic look.

"Or a mortal dread of stairs," I chipped in.

"Wins first prize!" declared the estate agent pointing at me and grinning.

"Don't tell me there's not a toilet upstairs?" asked my wife.

"Correctomundo yet again!" replied the estate agent, snapping his fingers and pointing at my wife.

Curiously by the time we had been upstairs and encountered more woodchip wallpaper than you would have thought feasible – apparently it would strip quite easily off the doors – there was some talk about potential. Although my wife also said it would have the potential to drive us round the bend.

"It's certainly what you might call a project," remarked the estate agent as a doorknob came away in his hand.

"Correctomundo," muttered my wife.

From the porch we could see for miles and we had to admit that the view of the house was vastly improved because it was behind us but there was something of the old ship in dry dock about it, just waiting to be rescued and relaunched.

We certainly had the wind for it. When my wife returned to the safety of the porch relatively unscathed I took her word for it that the garden was vast. It looked vast even from where I was sitting.

"Now then!" declared the estate agent suddenly. "Call me old fashioned but I've saved the best bit till last."

"You mean there's a best bit. Did you know there was a best bit?" my wife asked turning on me, her eyes widening with excitement but I just shrugged. I wasn't getting drawn into any nonsense about best bits.

At the end of the hall, the estate agent swept back a curtain in a plume of dust to reveal a door.

My wife looked at me slightly impressed.

The estate agent opened the door and reached for a light switch. Suddenly stone steps were revealed and the smell of all things ancient began to waft over us.

"Is it a dungeon?" I asked. "Because if it is then we'll buy the place right now."

"It's not a dungeon," said the estate agent with a degree of aplomb, "it's a multi-purpose sub-space."

My wife and I looked at one another and enthused loudly.

If it had been empty it would have been big enough to house a tube station.

As it was filled with the decaying, jumbled contents of at least three houses and several garages it was hard to tell which way up we were standing.

Dragging our way through the junk like explorers we came to a man-sized free-standing safe, which the estate agent seemed happy to ignore.

"Just think what you could do with this space!" he declared, nodding

away at what appeared to be the set for a remake of *Steptoe and Son* while we stared open-mouthed at the gigantic safe.

"They must have been minted," muttered my wife, then suddenly she spotted something in a dark corner that caught her attention. "Is that an upright fridge freezer?" she asked.

"Actually there are three fridge freezers down here somewhere," replied the estate agent perking up.

My heart sank. Even in the gloom I could see that look on my wife's face that said "Saddle up cowboy, it's wagons ho!"

The view of the house was vastly improved because it was behind us.

The Hogmanay Coat

YOU would almost have thought I'd planned it. Although, if I had, I wouldn't have made such a good job of it and the last thing I would have come up with as an excuse for not going out on Hogmanay would have been temporary disfigurement.

It's not the first thing that crosses your mind, but I think it crossed my wife's: she had bought a new coat and was desperate for it be launched into society.

Anyway, the herbal bath was my wife's idea, so I can't really take the credit for it. If you ever have a herbal bath, remember not to splash it over your face, or at least over my face.

In my defence, I had shampoo in my eyes and never gave it a second thought, until about half an hour later when I was clearing up the bathroom and I wiped the mirror and discovered I had turned into a boozy chipmunk.

This is not as exciting as it sounds and it's certainly not a sexy look if you're planning on going out.

"You could just say it's sunburn," suggested my wife, "lots of people go abroad for Christmas."

I wasn't so sure. Although it did look as if I'd been wearing sunglasses while sunbathing, or maybe even ski-ing.

I could have been mountain climbing, or flying a light aircraft with an open cockpit across the Alps.

It was time for another inspection in this new, more interesting light.

On either side of my nose, my face was bright red, blotchy and swollen enough to make me look as if I'd been too fond of the mincemeat pies and the sherry, rather than out being daring and adventurous. It certainly wasn't the kind of thing you could hide, although it crossed my mind. Apart from anything else, it was slightly painful.

"What about covering it up with cosmetics?" I asked my wife, who still refused to admit there was a problem.

"What about cosmetic surgery?" she replied. "Or you could go out in drag and I could make you up and then no one would notice a thing."

Apparently, this sort of Hogmanay haplessness runs in the family. My father once powdered himself down with Vim after a Hogmanay bath because it was in a fancy container and he assumed it was talc. After his umpteenth wash, he was still strangely restless. At least I could wear underpants.

"Anyway, it's dark," announced my wife. "Nobody will see you, even if you are wearing make-up."

"What if I meet some mates? They'll think I'm on the turn," I bleated, trying different faces in the mirror.

"Tell them it's a New Year resolution," suggested my wife.

That did it. Somehow, if I had to handcuff myself to the radiator, I was staying in. I kept quiet, though. There was no point in making bold announcements before I had a proper escape plan in place.

After ruminating, I rose eventually to the challenge and convinced myself it was actually a good idea to go out with a face like a proverbial slapped behind. Who cares, I said to myself, I'm too old to be vain.

There was also the coat.

My wife had been looking for this coat for what seemed a whole year. I was

only too willing to help her find it, pointing out anything I happened to pass in shop windows. Unfortunately, I had nothing to go on because she couldn't describe it to me, but apparently she would know it when she saw it.

"Is this it?" I would ask, holding up what I reckoned was a perfectly nice looking coat.

And then several months and several dozen coats later: "Surely this is it?"

But it never was. Not until Hogmanay when it appeared as if by Fairy Godmother magic in Markies. It was strangely quiet in town, and the whole day had a special, other-worldly atmosphere that made you think anything could happen, even the impossible, like for instance my wife finding that legendary coat and not only buying it, but actually keeping it.

It was short, navy blue and double breasted. Who would have thought?

It also had an unusually large dark-green button on one of the cuffs.

"Is that big button a feature?" I asked my wife as she modelled the coat in our bedroom.

Since I had managed to talk myself out of having a big red skelped face, the possibility of the coat making a public appearance was back on the cards.

"What big button?" she demanded, then screamed, then whimpered, then collapsed on the bed.

"It's not that bad," I said. "Maybe it's a design element."

"It's the flipping security tag," shouted my wife as she wrestled off the coat.

"Oh my God, how did we get it out of the shop without setting off the alarm? They'll think we've nicked it," I shouted, grabbing the coat and, as if we were about to be raided at any moment, giving the big green button a big serious tug.

To my amazement, it stayed put and instead, rather spookily, it began to bleed menacing dark-blue ink all over my hands, the jacket, and our lovingly hand-painted, off-white wooden floorboards. It just missed my new Christmas jumper, so it had another go and spat ink everywhere like a menacing squid.

This time, it covered our bedspread, which naturally was an heirloom minding its own business.

The ink started off dark blue, matching the coat, but then almost out of sheer nastiness out spewed some vile green bile.

Much wailing and weeping ensued, during which all Hogmanay festivities were cancelled – or at least diminished and a plot hatched to bring the M&S empire to its knees pleading for mercy.

While my wife tried to salvage the bedspread, I scrubbed my dark-bluish-green hands under scalding water until they looked as if they were covered in slightly faded boring tattoos. My cheeks, though, were now scarlet and pulsating like a pair of giant Christmas lights.

It was a strange, if memorable, Hogmanay, spent mainly trying to text and call for help through a network that had obviously collapsed under pressure.

My wife, meanwhile, held on to the revenge theme while shouting the word "Ruined" every ten minutes.

The manageress from Markies was horrified when she heard our scary tale.

"Please don't tell me you pulled the ink tag," she declared. Which was exactly the same thing everyone else said. When it happened to one of my wife's aunts, the shop in question sent round a manager in a taxi to remove the tag. There was to be no indelible-ink splattering around that pristine household, no ruined heirlooms or floorboards.

Still, we were amply compensated; my wife has a new coat and I have hands to match. I'm sure the nickname "Herbal Face" is only a temporary hitch.